Photography
FOR
DUMMIES®

Based on *Photography For Dummies*®

Russell Hart
With additional writing
by Dan Richards

WILEY

wiley.com

Photography For Dummies

Published by:
John Wiley & Sons Canada Ltd.
22 Worchester Road
Etobicoke, ON
M9W 1L1
www.wiley.ca (John Wiley & Sons Canada Ltd. Web site)
www.dummies.com (Dummies Press Web site)

ISBN 1-894413-50-4

Printed in Canada

2 3 4 5 TG 06 05 04 03 02

Distributed in Canada by John Wiley & Sons Canada Ltd.

For general information on John Wiley & Sons Canada Ltd., including all Hungry Minds publications, please call our warehouse, Tel: 1-800-567-4797. For reseller information, including discounts and premium sales, please call our sales department; 416-646-7992.

For press review copies, author interviews, or other publicity information, please contact our marketing department: Tel: 416-646-4584; Fax: 416-646-4448.

For authorization to photocopy items for corporate, personal, or educational use, please contact Cancopy, The Canadian Copyright Licensing Agency, One Yonge Street, Suite 1900, Toronto, ON M5E 1E5; Tel: 416-868-1620; Fax: 416-868-1621; www.cancopy.com.

Contents at a Glance

Publisher's Acknowledgements

We're proud of this book; please e-mail us your comments to `canadapt@wiley.com`.

Some of the people who helped bring this book to market include the following:

Acquisitions and Editorial

Executive Editor:
Joan Whitman

Associate Editor:
Melanie Rutledge

Copy Editor and Proofreader:
Michael Kelly

New Business Development Manager:
Christiane Coté

Production

Publishing Services Director:
Karen Bryan

Layout and Graphics: Kim Monteforte,
Heidy Lawrance Associates

General and Administrative

John Wiley and Sons Canada Ltd.:
Diane Wood, President; Robert Harris, Publisher

Introduction

· ·

*I*f I asked you to name your most valuable possession, what would you choose? At first, you might say your wedding ring, your car, or your house, but after further thought (a little coaxing from me), you would probably arrive at this conclusion: your photographs. The funny thing is that most people aren't entirely happy with their photographs. You may be one of these slightly disheartened shooters. You probably think that your pictures could be better — if not more artistic, then more colourful, more interesting, or just plain sharper.

But if you've been blaming your camera for your photographic unhappiness, I'm here to tell you that it's the least likely culprit. Today's point-and-shoot cameras are remarkably reliable devices, especially considering all the stuff that they do, and yours is probably doing its job pretty well. So why aren't your pictures better? You may just not know the right button to push — and believe me your point-and-shoot has a magic button or two. The main secret of better photographs is knowing what to shoot, when to shoot it, and how to shoot it: how to squeeze your subject meaningfully into the little patch of visual real estate called a print. You need *Photography For Dummies* because it lets you in on this secret.

How This Book Is Organized

If you want to take better pictures, you have to take lots of pictures. And taking lots of pictures is the only way that you can see for yourself the actual effect of the things that this book asks you to try. So before I get into the nuts and bolts and pushbuttons of the photography craft, I do the basics, giving you just enough to get started shooting. Later in the book you'll find handy tips and tricks for taking better pictures and some essential lists to improve your snapping ability.

Icons Used in This Book

The margins of this book are wide for a reason: They contain icons — cute little symbols — that identify particular kinds of photo hints and helps. (No connection to the icons that your camera uses to indicate settings!) Here's what each icon means:

Follow this icon's advice (always simple and straightforward), and your pictures should hit the mark.

This icon's fuzziness suggests one possible consequence (blurred pictures) of committing the sorts of photographic *faux pas* that it describes.

I recommend picture-taking experiments throughout this book, highlighted by this icon. Call them exercises — sort of like photo aerobics.

Information for those who want to know photography's *whys* along with the *hows*, this stuff is really never very technical — so I hope everyone reads it.

Chapter 1

Getting to Know Your Point-and-Shoot

In This Chapter

▶ Installing batteries

▶ Loading film

▶ Turning on the camera

▶ Holding your camera

▶ What to do if you accidentally open the camera back

▶ Rewinding do's and don'ts

*Y*our point-and-shoot camera is practically an invitation to just start taking pictures. A wonder of automation, it uses advanced electronics and tiny motors to quickly execute the many steps that photographers used to have to do manually each time they wanted to take a picture. Point-and-shoots automatically advance the film from shot to shot. They automatically compute the correct exposure — the exact amount of light that your film needs to properly record the subject — and adjust camera settings accordingly. They automatically turn on the flash in dim light. And they automatically focus the lens.

Actually, your particular point-and-shoot may not perform every one of these functions. And which ones it does perform depends partly (though not entirely) on what type of point-and-shoot you have. So this chapter begins — a chapter otherwise devoted to getting you taking pictures as quickly as possible — by describing the four different types of point-and-shoot cameras.

Point-and-Shoot Cameras

Point-and-shoots have more in common than they do differences, especially in how you operate them — what you push, slide, or twist to make them do specific things. But while they're operated in much the same way, point-and-shoots differ both in the way the image is captured and in the mechanical and electronic complexity they bring to the job, making it possible to divide them into four main types.

35mm point-and-shoots

Granddaddy of the point-and-shoots, the 35mm point-and-shoot uses 35mm film — the film that comes in the funny-looking little cassette with the perforated tongue sticking out. These point-and-shoots come in every form from cheapo check-out counter specials to expensive, full-featured models that rival 35mm single-lens reflexes (those professional-style system cameras) in their sophistication.

Advanced Photo System point-and-shoots

The next generation of point-and-shoot camera, Advanced Photo System (APS) models usually look just like their 35mm counterparts. They take a special, smaller-than-35mm film cassette that not only lets manufacturers create smaller cameras but also simplifies film loading, improves the photo-finishing quality, makes storage and reprinting easier, and (most fun) gives you a shot-by-shot choice of three different print sizes, which you select with a switch on the camera.

One-time-use point-and-shoots

They're everywhere. From drugstores to Disney World, one-time-use cameras are the most popular point-and-shoot models, outselling reloadable models by more than six to one. These inexpensive (usually $7 to $15) models are in some ways the ultimate point-and-shoot. They're ready to roll — film and batteries preinstalled.

Digital point-and-shoots

Unlike other point-and-shoots, a digital point-and-shoot doesn't use film. How can it capture photographs without film? The same way video camcorders do, with an electronic light-sensing "chip." But unlike most camcorders, a digital camera stores photographs as digital files that can be downloaded directly to a computer for retouching, e-mailing, and printing. Yet in terms of operation, digital point-and-shoots are essentially like film-using cameras — most of the shooting advice in this book applies to them as well.

The Parts of Your Camera

Here are a couple of things to remember as you begin to get the feel of operating your camera. First, your camera is basically a lightproof box, protecting the film inside from any light other than what the lens gathers from the subject and uses to form a picture on the film's surface. Second, the camera is basically an extension of your eye — a window on your subject. In fact, to view your subject you look through a little window on the camera back called the *viewfinder*.

Now for those pushbuttons. When it comes to the design and location of your point-and-shoot's controls, little standardization exists. Two very different-looking controls in two very different places may do pretty much the same thing. But whatever the control configuration, all but the least expensive models have an LCD panel — a *liquid crystal display* on the top or side of the camera — that indicates what settings you're making. Figures 1-1 and 1-2 show the location of camera controls and other basic camera features for a typical Advanced Photo System point-and-shoot and a typical 35mm point-and-shoot. Your camera may be different from the models shown — the only way to know is to check your camera manual.

Batteries: The Pluses and Minuses

Point-and-shoot cameras are full of little motors that do every-thing from advancing and rewinding your film to zooming your lens. These motors are highly efficient, but they consume quite a bit of electricity. Makers of kids' toys have a simple

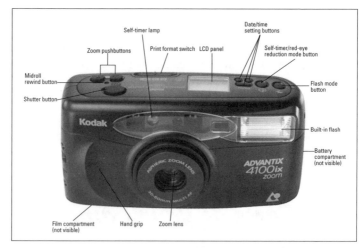

Figure 1-1: The controls and features of a full-featured Advanced Photo System point-and-shoot.

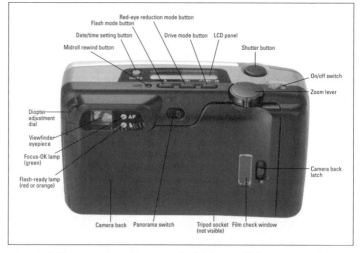

Figure 1-2: The controls and features of a full-featured 35mm point-and-shoot.

solution — use more batteries. But because a point-and-shoot must be compact, manufacturers have a different strategy: use smaller, more powerful, longer-life batteries.

Lithium batteries

Many, if not most, point-and-shoots are powered by special *lithium batteries.* Made for use in cameras, these cells are shorter than AA batteries, but a lot more expensive. The most common type of lithium battery is a three-volt cell that goes by proprietary designations such as KL123A, CR123A, or DL123A (a 123A is always in there). What's more, some cameras need two three-volt lithium batteries. And some take double-barreled six-volt batteries.

Fortunately, lithium batteries last longer than AAs. But the number of pictures you actually get out of a lithium battery depends on the power needs of your camera; the more motorized it is, the fewer the rolls. Most models give you within the range of 10 to 25 24-exposure rolls per battery, assuming that you use flash about half the time.

When you need a new battery, always take the old one — or better yet, your camera — to the store. Given all the different types of batteries, not knowing which one you need drives clerks crazy. By taking your camera and putting in the new battery at the store, you're immediately reassured that you've brought your camera up to snuff.

Recycling woes

As a battery weakens, your camera's flash takes longer to *recycle* — to recharge itself for the next flash picture. This sluggishness becomes a practical problem if, as with most point-and-shoots, your camera won't let you shoot until the flash has mostly recycled.

You can turn off the flash (which otherwise powers up automatically every time you turn on the camera) to side-step this problem. But flash is one of the most valuable photographic tools on your point-and-shoot, and you should use it generously — even outdoors!

If your camera's shutter button won't let you take a picture, don't keep bearing down on it. The camera may still be recycling the flash, preventing you from shooting to reduce the chance of a bad picture. Release the pressure, wait a few seconds, and then press again.

The good old AAs

Some point-and-shoots use AA (or AAA) batteries, the same sizes that go into most battery-powered gizmos. These models tend to be less expensive, economizing further by avoiding special lithium cells. If you have such a camera, be sure to use alkaline AA (or AAA) batteries and not the standard cheapo batteries. Alkalines last many times longer than regular batteries.

Loading batteries

If you've ever had to figure out where to stick batteries in your child's latest electronic acquisition, then loading batteries in your point-and-shoot shouldn't be a challenge. Turn off your camera when you install them; the camera may go crazy opening and closing its lens. (Some cameras turn themselves off after you install new batteries, so you have to turn them back on to shoot.)

With big point-and-shoot models, you typically open a latched cover on the bottom to install batteries. More compact models have a battery compartment under a door or flap that is incorporated into the side or grip of the camera. You may have to pry open such doors with a coin.

More annoying are covers on the bottom that you open by loosening a screw. (You need a coin for this type, too.) And most annoying are battery covers that aren't hinged and come off completely when you unscrew them. If you have one of these, don't change batteries while standing over a sewer grate, in a field of tall grass, or on a pier.

Whether loading four AAs or a single lithium, make sure that the batteries are correctly oriented as you insert them. You'll find a diagram and/or plus and minus markings, usually within the compartment or on the inside of the door.

If your camera doesn't turn on and the batteries are correctly installed, the batteries may have lost their punch from sitting on a shelf too long. Which is where the battery icon comes in. If your camera has an LCD panel, an icon tells you when battery power is low.

Typically, if the icon's shape is fully darkened, the battery has sufficient power. If it's half darkened, you've already used a good portion of its juice — and may have noticed already that the flash recycling time is increasing. If the icon is barely filled in and/or blinking, you need a new battery. (See Figure 1-3.)

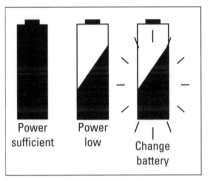

Power
sufficient

Power
low

Change
battery

Figure 1-3: Typical battery power icons.

Some models display battery status all the time. Other models won't display the icon at all until the battery is on its way out. And still others have a pushbutton battery check. Pushing the button makes a light glow. However your camera displays battery status, check the status regularly. If you're shooting a special event or going on a trip, check it before you go. If the battery needs replacing, do it now.

By the way, changing batteries when film is in the camera is perfectly okay. The LCD panel goes blank during the change. Even though the LCD is battery-dependent, the camera "remembers" how many pictures you've taken — or how many are left, depending on your model — and restores the display after you power up again. Models with mechanical counters remain unaffected. The camera ordinarily *doesn't* remember specific settings that you previously made, however. (See Chapter 2 for more on setting camera modes.)

If you don't use your camera for a long time — a couple of months or more — remove the batteries to prevent the possibility that they'll leak corrosive fluids. (Remember that you lose the frame count, but you probably shouldn't leave film in that long anyway.) Leakage, most likely with AAs, can seriously damage your camera's innards.

Loading Film

Probably the single greatest source of photographic anxiety, loading film is much easier than it used to be, thanks to point-and-shoot innovation. The Advanced Photo System's near-foolproof film cassette and drop-in automatic loading is the easiest — check your camera's manual for tips and tricks. This section, however, covers loading film into a 35mm point-and-shoot.

Most 35mm point-and-shoots have automatic film loading. After you close its back, the camera automatically advances the film to the first frame. But what cows people is the film *leader* — the strip of film that protrudes from the cassette's lightproof lip. From the lip, the leader is perforated on both sides (as is the film inside the cassette), but it tapers to a short half-width strip with perforations only on one side. After the cassette is in position inside the camera, you pull the leader across to the film *take-up spool,* which automatically engages it after you close the camera back.

Here's how loading a 35mm point-and-shoot works:

1. **Open the camera back.**

 A latchlike sliding switch (usually marked with an arrow or the word *open*) is on the side or back of the camera. You may have to hold down a locking button as you move the switch; this catch lessens the chance that the back would accidentally pop open and ruin your film when shooting. The back clicks open on the latch side; lift it up so that you can put in the film. (The camera can be off or on when you load the film.) See Figure 1-4.

 In the middle is a rectangular opening though which you can see the back of the lens. This opening is where each frame of film rests as you shoot it. On either side of this rectangle are two chambers. The large, empty one is where the film cassette goes. With some models, it's on the left; with others, it's on the right.

2. **Nestle the film cassette into the empty chamber.**

 You can't just drop the cassette in. Notice that the cassette has a small cylindrical protrusion at one end, called the *spool hub.* This protrusion fits into a small

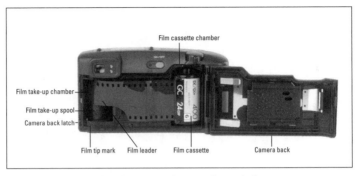

Figure 1-4: The view inside an open 35mm point-and-shoot.

recess in the film chamber. Also, a spindle extends into the film chamber, from the top or bottom. You have to slip the flat end of the cassette — opposite the spool hub — over the spindle as you fit the cassette into the chamber, sometimes with a little nudging and wiggling.

3. **Grasp the leader and pull enough film from the cassette so that the leader's front edge lines up with the *film tip mark* in the opposite chamber.**

 The film tip mark is often, though not always, orange or red. As you pull on the leader, keep a finger on the cassette so that it doesn't lift out of the chamber. Lie the film flat across the rectangular opening to see if it reaches the mark. If it doesn't, pull it out a little more.

 As you get more comfortable pulling film out of the cassette, use your thumb to press against the top edge of the film and push it along its path, as shown in Figure 1-5. This technique helps you gauge how much film to pull out. Just be sure not to press against the rectangular opening.

 With compact cameras, you don't need to pull the film out more than a few perforations' worth; with bigger models, rarely more than ½ or ¾ of an inch. But you don't have to be precise about the amount of film you pull out. Some models seem more able than others to handle excess film. None, however, can grab the leader if it's too far away. So err on the side of more film rather than less.

4. **Now press the whole film strip flat against the rectangular opening, double-check that the cassette**

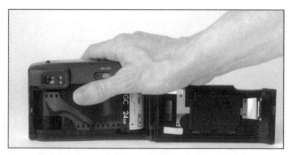

Figure 1-5: You can extend the film's leader by sliding it across with your thumb.

is snugly seated, and then close the camera back with firm pressure until it clicks.

The camera's take-up mechanism and winding motor should engage the film and advance it to the first frame. The camera's frame counter or LCD panel then displays the number *1*.

If nothing happens after you close the camera back, you may have to turn your camera on to advance the film. If it still doesn't advance the film, try pressing the shutter button once. (A few inexpensive models may require that you push the shutter button repeatedly until the number *1* appears in the frame counter.)

Fortunately, a 35mm point-and-shoot tells you (after you close the back and it attempts to engage the leader) if you pulled out too much film — or if you didn't pull out enough. It gives you this warning, if it has an LCD panel, by blinking an icon of the film cartridge and/or the number *1* or an *E* (for empty). Models without LCD panels simply fail to move their mechanical frame counters to *1*.

To fix this, open the camera back. Pressing the film flat against the camera, check to see that the leader lines up with the film tip mark. If it's short, pull out a little more film and close the camera back.

If you pulled out too much film, take out the cassette. Hold the cassette between the thumb and fingers of one hand and point the spool hub toward you. Grasp the spool hub with the thumb and forefinger of your other hand and rotate it counter-clockwise to *draw the leader back into the cassette.* Rotate it *slowly,* so that you don't accidentally pull the whole leader back into the cassette.

Some 35mm point-and-shoot brands use a drop-in loading system that is fairly foolproof, as such things go. The cassette slips into a shaped compartment on the *bottom* of the camera. You do have to pull out the film leader a bit so that the camera can engage it after you close the door, but the compartment is shaped so that you can clearly see how to insert the cassette.

Counting up — and down

After you load the film, the camera automatically advances it from one shot to the next. If your camera is an inexpensive model, you may have to advance the film by rotating a thumb-wheel after every shot. You can't overwind: The wheel, which is located in the upper right of the camera back, stops when the next frame is lined up.

Most 35mm models count exposures upwards — 1, 2, 3, and so on, all the way to the last frame on the roll. (Rolls of 35mm film come in 12, 24, and 36-exposure lengths.) Displayed either by a mechanical counter under a small window (usually on the camera top) or by the camera's LCD panel (if it has one), the frame number is actually the number of the frame that you're *about* to shoot. If it says 18, you've taken 17 pictures and are about to take number 18.

Some 35mm models count down — 24, 23, 22, and so on, all the way to 0. The number that they display tells you how many frames you have left on the roll.

Fogging film

When you open the camera back before the film is fully rewound, the resulting exposure to incoming stray light is said to fog the film. *Fogging* clouds up, discolours, mars with streaks, or obliterates the pictures that you've shot — assuming that you get them developed.

Fogging almost certainly ruins your most recent shots. But if you close the camera back quickly, some earlier pictures on the roll may be salvageable as the film is opaque before development and forms a tight coil on the take-up spool as you shoot — the top loop or loops protects the film beneath. But the longer you leave the back open, the more damage is done. And the brighter the surrounding light, the more

immediate the damage. You don't know how bad the damage is until you have the film processed, which is worth doing. The photofinisher does not print badly fogged frames, so you don't have to pay for them.

If you open the camera in the middle of the roll, the film you *haven't* used yet is still safe in the cassette and, with the exception of a frame or two, should be unfogged. In fact, after you close the back, the camera may behave as if you've loaded a new roll and advance the film to what it thinks is the first frame — pulling out enough film to reach the unfogged portion. But to be safe, fire off a few blank frames (shots of nothing in particular) to advance the roll further, and you're ready to keep shooting. Keep in mind that the frame counter is reset to 0 after you open and close the back; unless you remember how many frames were left on the roll, you don't know exactly when it will end.

35mm models that count frames down may also prewind the film. Prewinding means that when you load the cassette and close the camera back, the film advances all the way to the last frame. You hear motors whirring for quite some time, and you may see counters counting up along the way. Then, as you take each picture, the film is drawn, a frame at a time, back into the cassette. (Rewinding is short, because at the end of the roll only a few inches of film are left!)

The thought behind prewinding is sensible: If you open the camera back accidentally in the middle of the roll or drop the camera and the back pops open, frames that you've already shot are safe inside the cassette. With a prewinding camera, the only film that is fogged by the light let in is the film outside the cassette — with no pictures on it.

If you have a prewinding camera and accidentally open the back in the middle of a roll, close it and rewind the film. (Check out "Rewinding Film," later in this chapter, for instructions on mid-roll rewinding.) Do not shoot any more pictures; you'd be taking them with fogged film, and they probably wouldn't come out. If you shut your camera really fast, you may have a few good frames near the end of the roll, but why take the chance? The photofinisher doesn't print what you don't shoot and certainly doesn't print fogged negatives. Remember, film is cheap.

Turning the Camera On and Off

Most point-and-shoots, whether Advanced Photo System or 35mm models, are turned on with a single pushbutton on the top or back of the camera. Push it once to turn the camera on and again to turn the camera off. Other models may turn on and off with sliding switches, also on the top or back. Some switches have two positions; others have a spring mechanism that returns them to a single position. (Slide them once to turn the camera on and again to turn the camera off.) Some cameras have sliding on/off switches on the front, usually below the lens. These switches also open the camera's built-in protective lens cover, so slide them back to close the cover and turn off the camera.

Other models are turned on and off with a large, sliding front panel that doubles as a lens protector. Sometimes called a *clamshell* cover, a term inherited from older cameras that had swing-out front covers, this design is very sensible. To open and turn on the camera, simply use the flats of your fingers to slide the cover to the side. (The cover usually has a ridge to help you grasp it.) To turn off the camera, slide the cover back over the lens. With some designs, you have to wait for the lens to retract before sliding the cover all the way over.

One other style of on/off switch is increasingly common, built into a thumb-controlled dial on the camera's back or top. The dial has various settings on it, including one marked *A* or *Auto,* or sometimes just plain *On.* (This setting may be colour-coded green, for *go.*)

As you turn the camera on, the lens is uncovered. This function may be strictly mechanical, as with sliding front panels or below-the-lens sliding switches. Otherwise, it's done with motor-driven spring action.

Some lens covers are large, flat doors that are flush with the front of the camera; after you turn off the camera, they hide the entire lens, cylindrical barrel and all, within the camera body. Other lens covers are made of delicate blades that are built into the lens barrel and spring open to uncover the glass portion of the lens. Whatever the design, the lens cover protects the front glass surface of the lens from smudges or scratches. If your camera has a bladed cover, be advised that if you leave it in a purse or carryall, the cover blades can catch on something

and be pulled open, subjecting the lens to scratching from keys and so on. If you stash your camera in a bag, keep it in a fitted pouch.

Point-and-shoot cameras with sliding front covers are a smart idea. The lens is more protected than with other designs, making the camera ideal for slipping into a pocket or purse.

Some models dispense with moving lens covers altogether. They use a clear, flat piece of glass to protect the more delicate glass of the lens. This glass cover remains in place whether the camera is on or off, so it's very susceptible to smudging when you're just holding or carrying the camera. Whether on a cover glass or on the lens itself, smudges are one of the main causes of photos lacking sharpness.

After you turn your camera on, it may extend the lens, especially if it's an autofocus model. (Many cameras extend the lens as the cover is opening.) Extending the lens readies the camera for shooting; with zoom models, it sets the lens to its shortest (most wide-angle) focal length, generally 35mm or 38mm, though sometimes 28mm. (These settings are different for APS cameras; Chapter 3 has more on focal lengths.) You can then zoom to the setting of your choice. If your camera does not have autofocus, the lens may not need to move at all.

Get a Grip: Holding Your Camera

Point-and-shoot cameras are often so small — and so crowded with buttons, dials, windows, and other doodads — that you usually have little leeway when holding them to take pictures. You basically have to pinch each end of the camera between your thumb and fingers, except that your right index finger must rest on the shutter button on top of the camera. Your remaining three right-hand fingers form a sort of wedge against the front of the camera. Many models incorporate a curved or ridged grip on the right side, making for a more secure grasp and, coincidentally, a nice little space for the battery compartment.

Your right thumb should rest vertically against the back of your camera. With most zooming models, the zoom control is at the tip of your thumb, in the upper right of the camera back. But some models have zoom controls on top of the camera, which you operate with your right index finger. You have to get

used to moving your finger back and forth between the zoom control and the shutter button. You will.

You have a little more flexibility with your left hand, though the best way depends partly on the specific design of your camera. The worst thing that you can do is to stick a finger over the flash, ruining indoor pictures (see Figure 1-6, top left). Find a comfortable way of grasping the camera that avoids this problem and use it consistently.

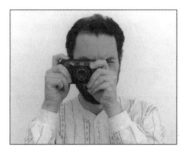 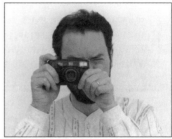

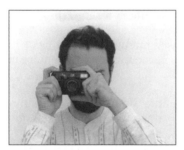 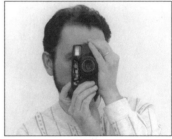

Figure 1-6: The steadiest grip on a camera is often the most comfortable one — but never cover the flash (top left).

As far as your left thumb goes, you can match the position of your right thumb: point it up and slightly inwards. The front of the camera then rests against the side of your index finger (see Figure 1-6, top right). A better left-hand grip places the thumb against the bottom of the camera, and, preferably, the index finger across the top (see Figure 1-6, bottom left). You just have to hold your other fingers away from the camera (again, to avoid blocking the flash) either by folding them in tightly or splaying them out, which looks a little ornate. (If your camera has a flash that pops up on top or pushbuttons on top that you may accidentally press, you should avoid this technique.)

For vertical shots with flash, try to place the camera's built-in flash at the top rather than the bottom; this creates a more flattering effect with people pictures (see Figure 1-6, bottom right).

How to press the shutter button

Don't treat your shutter button like a hot potato! Stabbing it causes the camera to jerk — unintended movement is one of the main causes of unsharp pictures. Instead, rest your finger lightly on the shutter button. When you want to take a picture, slowly, smoothly bear down on the button until the shutter clicks. Then release the button without completely removing your finger. Pretend that your shutter-button finger is glued on: Keep it there before, during, and after snapping a picture.

Rewinding Film

When a point-and-shoot camera reaches the end of a roll of film, it automatically *rewinds* it — that is, the camera draws the entire roll of exposed but undeveloped pictures back into the cassette. Less expensive models may require manual rewinding with a crank.

A 35mm camera has a little window on the back through which you can see a small portion of the film cassette, including the number of frames it holds. If the camera counts exposures upwards, as most do, this information lets you determine when you're nearing the end of a roll. With an APS camera, you probably don't have to figure out how many frames you have left; most APS models count frames *down,* telling you how many exposures are *left* on the roll.

A few high-end APS cameras have a feature called *mid-roll change* (MRC), allowing you to swap film cassettes without wasting a single frame. How? When you put a previously rewound roll back into your camera, the camera remembers where you left off — advancing the film to the first unexposed frame beyond.

If you've read this chapter and still face the ultimate frustration — your camera just won't shoot — go directly to Chapter 10 for some succinct suggestions to get your point-and-shoot shooting again.

Chapter 2

Pictures à la Mode

. .

. .

A funny thing happens when you show good pictures to people. Ever notice it? You take out some well-focused, colourful, nicely composed photos, pass them around to your friends, and they oooh and aaah. "Wow!" they say. "What a great camera you have!"

Your camera does have a great deal to do with how your pictures turn out. And so do you. You can't leave all the decisions up to your partner, the camera, if you want to get beyond okay-but-not-great pictures. *You* have to call the shots — or push the buttons.

The Great Button Bazaar

You have more to say than you may think in the many decisions your all-automatic camera makes each time you take a picture. And the way you get your say, on most point-and-shoots, is with those pushbuttons.

Most point-and-shoots have several buttons to push besides the most obvious one, the shutter button. These buttons are frequently next to the camera's *LCD panel* — the silvery little screen that shows you, among other things, how much film you've used. This panel is commonly on the top of the camera, but you may also find it on the camera's back. Regardless of

the panel's location, you'll probably find additional buttons in other places — next to the camera's viewfinder, on the camera's side, or even squirreled under a sliding or hinged cover. Figure 2-1 shows a typical array of pushbuttons.

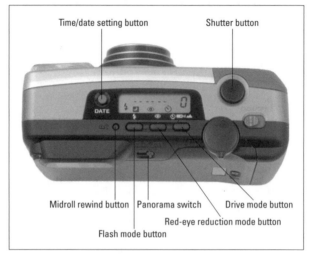

Time/date setting button Shutter button

Midroll rewind button | Panorama switch Drive mode button

Red-eye reduction mode button

Flash mode button

Figure 2-1: Pushbuttons on a typical point-and-shoot let you set everything from flash modes to the self-timer.

 Dials are now replacing buttons on many point-and-shoot cameras. They do the same thing as buttons. Dials simply show you more of your optional settings at a glance (see Figure 2-2).

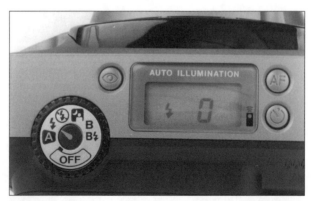

Figure 2-2: Many point-and-shoots now substitute dials for pushbuttons.

Why all the extra buttons or dials? To let you set camera modes according to your pleasure, creative needs, and photographic purposes. Understanding and using the camera's different modes, features, and functions allows you — with no muss or fuss — to get a much higher percentage of keepers.

Mastering Your Camera's Modes

Mode is a modish word in photography today. Even a fairly simple point-and-shoot can have several flash modes, focusing modes, and drive modes. So just what is a mode anyway, and why is it important?

A *mode* is a set of instructions that tells the camera to operate in a certain way. Point-and-shoot cameras may seem smart, but like computers, they're really dumb. Like computers, they have to be *told* to do everything they do — every time they do it. In fact, a small computer in your point-and-shoot carries out a mode's electronic instructions. In fact, some camera makers call modes *programs.*

Even if you've never touched any control except the on/off switch and the shutter button, you've set the camera to a mode — many times, in fact. When you turn your camera on, it sets *itself* to a default mode. This mode is usually called *autoflash* because it automatically fires the camera's built-in flash, if needed.

Buttons to Push and Dials to Turn

The typical way to change a mode is to press a button on the camera and watch as symbols (icons) or words representing each mode appear on the LCD panel. Repeatedly pressing the button to move through the modes is called *toggling.* If you keep pushing the button, you eventually return to the default mode to start all over. Toggle through the modes as many times as you like to find the one you want.

If your point-and-shoot uses dials rather than pushbuttons, mode icons are printed around a dial's edge. This arrangement lets you see all the icons at once, instead of viewing them sequentially as with a pushbutton. You simply rotate the dial

to the icon for the mode that you want. Another kind of dial actually changes the icon on the LCD display or moves an LCD pointer from icon to icon as you rotate it.

A common arrangement on point-and-shoots is one button that toggles through flash modes and a second one that toggles through the remaining modes. Some cameras have a dial only for flash modes (they're so important and should be easier to access), relegating other modes to a button. Some cameras have two dials; some have two dials and a button; some have four, five, or six buttons. . . .

Alas, no standard point-and-shoot control configuration exists; every manufacturer uses its own arrangement. Nor have manufacturers settled on standard icons for different modes. The only surefire way to find out what the icons on your camera mean is to check the manual.

Millions of Modes?

Counting all the modes available on current point-and-shoots can add up to about 30. Fortunately, no single camera has them all, though some fancier models come pretty close.

You can divide modes into groups, depending on what part of the camera they control or what kind of picture they're designed to help you take, and the following explanation of different modes does just that.

Most point-and-shoots have no more than a half-dozen modes. Even if your camera has more, you'll use only a few with any regularity, and those are included in this chapter. Some modes, on the other hand, you may never use at all. To find out which modes you can ignore, you first have to know which ones your point-and-shoot has and what they're good for, or at least intended for. Sit down with your camera and manual, and decide which modes you're likely to use.

Flash modes

Flash modes let you change how and when the flash fires — or let you turn it off entirely. If a point-and-shoot has any modes at all, flash modes usually get their own button or dial. They're that important. Use flash modes well, and you'll see

noticeable — maybe even astonishing — improvements in your pictures. Chapter 5 has more about flash modes, the most useful modes on your camera.

✔ **Autoflash mode:** You find this mode (see Figure 2-3) on just about any camera above the one-time-use level. Autoflash is the universal default mode. Autoflash gives you flash when needed, turns the flash off when light is bright, and does its best to keep shots from blurring. When in doubt, leave your camera in autoflash mode so that you can turn on the camera and shoot!

Figure 2-3: Typical icons for autoflash mode.

✔ **Fill-flash or flash-on mode:** Fill-flash mode (see Figure 2-4) is present on point-and-shoots above the most basic level. This mode turns on the flash and keeps it on, no matter the lighting conditions. Fill flash is the mother lode of modes — perhaps the single most important camera setting within your control. It's essential for lightening harsh shadows in outdoor portraits and the best choice for brightening subjects lit from behind.

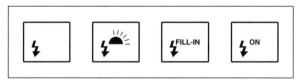

Figure 2-4: Typical icons for fill-flash mode.

✔ **Flash-off mode:** Found on most models above the very basic, this mode (see Figure 2-5) turns off the flash and keeps it off no matter the lighting. Use it to preserve interesting natural light when flash would overpower it. Of course, if the light is bright enough, the flash turns itself off in autoflash mode. But flash-off mode ensures that the flash won't fire. Definitely set it for low-light scenes that are beyond the range of flash, such as a sunset.

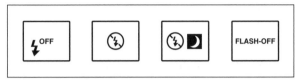

Figure 2-5: Typical icons for flash-off mode.

✔ **Slow-sync flash mode or night flash mode:** A feature on many cameras at $100 and higher, slow-sync flash mode (see Figure 2-6) works like fill-flash mode, except it's designed specifically for low light. In addition to firing the flash, slow-sync allows the shutter to stay open longer than usual, helping the film capture more of the existing light behind and around your subject. In practice, this mode improves background detail. (On some cameras, slow-sync flash automatically adds red-eye reduction.) Great use: a portrait in front of city lights or a sunset.

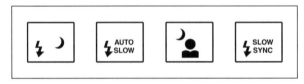

Figure 2-6: Typical icons for slow-sync flash mode.

Print-format modes

Everyone's familiar with the 4 x 6-inch shape of standard prints. (The 3½ x 5-inch size, once the standard and still available, has similar proportions.) A few 35mm cameras and *all* new Advanced Photo System cameras (except some one-time-use models) let you choose a differently shaped print called a *panorama.* Panoramic prints are long and narrow — 4 x 10 inches or 4 x 11½ inches, depending on the photofinisher. With the right subject, a panorama can be lots of fun, even verticals. But for most of your picture taking, the 4 x 6-inch size is the best and most economical choice.

Drive modes

Most point-and-shoots above $30 have motorized film winding, and most people take it for granted. Shoot a picture, and the

camera goes "BZZZZT," advancing the film to the next blank frame. But drive modes, if your model offers a choice of them, let you alter the way your camera goes about the business of winding, including firing your camera without a finger on the shutter button, such as the self-timer.

✔ **Self-timer mode:** On nearly all point-and-shoots other than one-time-use models, self-timer mode (see Figure 2-7) delays the picture taking by a set interval, typically 10 or 12 seconds. You place the camera on a nearby secure surface — a table (indoors) or a rock (outdoors), for example — aim it, and then press the shutter button and double-step to get yourself into the picture. The ability to include yourself in your pictures makes the self-timer much beloved by vacationers and party-goers, but it's useful in another way, too: It lets you keep your hands entirely off the camera when it fires. A good handmaiden to the flash-off mode, it eliminates the risk that shaky hands will blur the picture when the camera sets slow shutter speeds for low-light shots.

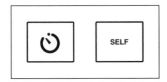

Figure 2-7: Typical icons for self-timer mode.

✔ **Remote control mode:** This mode (see Figure 2-8) is available on many cameras over $100, though the remote controller is usually an extra-cost accessory. Remote control functions much like the self-timer, eliminating hands-on firing of the camera. It works like your TV remote: You take the picture by pointing the remote controller at the camera and pushing a button, which fires the camera almost immediately rather than after a delay. Setting remote control mode activates the camera's *remote receptor* (an electric eye on the front of the camera that sees the beam from your remote controller) and tells it to look out for incoming photons. Keep in mind that the remote's beam range is usually limited to 20 feet or so, and the controller must be in a direct sight line with the camera.

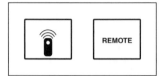

Figure 2-8: Typical icons for remote control mode.

Use remote control mode to steady the camera for any low-light photograph, just as you would with the self-timer, placing and firing the camera on a secure surface rather than holding it. And remote control is faster: You don't have to wait 10 or 12 seconds for the camera to fire as you do with the self-timer.

Focusing modes

Less expensive point-and-shoots use a fixed-focus lens design that tries to make everything reasonably sharp from around four feet on out. These *focus-free models* do eliminate the need to think about focusing. You get better results with cameras that focus their lenses automatically. But you do have to give focusing some thought — and know when to push the right button — to fully reap their benefits. (See Chapter 4 for more on focusing.)

 ✔ **Infinity lock mode or landscape mode:** Infinity lock (see Figure 2-9) may sound like a doohickey on the warp drive of the Starship Enterprise, but it's actually a feature on most autofocus point-and-shoots. It overrides the camera's autofocus, setting the lens to focus far away — no ifs, ands, or buts. Use this mode when photographing a landscape that doesn't have any important foreground detail or when shooting through glass, which can confuse many autofocusing systems. (This mode also turns off the flash as it may reflect in a window — and isn't powerful enough to light a distant landscape anyway.)

Figure 2-9: Typical icons for infinity lock mode.

✔ **Spot autofocus mode:** Many point-and-shoots now feature *wide-area* autofocus. In this default mode, the camera can often tell when the subject is not perfectly centred in the frame, correctly focusing it when other models may mistakenly focus on the background. Setting spot auto-focus (see Figure 2-10) disables wide-area autofocus and limits the focus point to a smaller, central area instead, giving you greater precision in the placement of the focus point. (Note that spot autofocus is often automatically set in tandem with another mode, *spotmeter.*)

Figure 2-10: Typical icons for spot autofocus mode.

Subject or picture modes

The idea behind subject or picture or program image modes (all three mean the same thing) is simple: Optimize the camera's various settings for a certain kind of subject, whether portraits, action, or landscapes. If you're still puzzling over all your camera's flash and drive and focus modes, setting, for example, portrait mode when you're taking a portrait gives you a quick starting point without fussing and fuming over a bunch of buttons.

✔ **Action mode:** You find this mode (see Figure 2-11) on higher-priced point-and-shoots, one of the few modes that has a nearly standardized icon. With most models, action mode sets the drive mode to continuous wind, in which the camera keeps shooting until you release the shutter button. Other models also turn off the flash, which makes sense; waiting ten seconds for the flash to recharge is hardly the way to snap fast sequence pictures.

Figure 2-11: A typical icon for action mode.

Action mode can help you capture moving subjects, but the only surefire way to get your point-and-shoot to set a higher, more action-stopping shutter speed is to use faster film.

✔ **Portrait mode:** Often found on the same upper-crust cameras that have action mode, portrait mode (see Figure 2-12) is another mode that varies in operation from model to model. But with many models, this mode sets an *autozooming* or *autoframing* function. (Some models even call it "Autozoom" mode.) Autozooming? Yes. Touch the shutter button lightly to focus and the lens automatically zooms to produce a half-height portrait.

Figure 2-12: A typical icon for portrait mode.

Something else to keep in mind: Portrait mode is designed for photographing people. Focus on a tree at a middling distance, and it will zoom in to get a shot of the trunk, which can drive you a little crazy after a while. Make sure to switch your camera out of portrait mode after you're done with the people shots.

Metering modes

Using its built-in light meter, your point-and-shoot measures the light level in the scene you're photographing. The meter uses this information to set the camera so that the film receives the amount of light it needs for a correct exposure. Point-and-shoot meters can be quite sophisticated; they may be able to detect strong backlight, for example, and automatically tell the camera to fire the flash or add exposure to compensate for it. But in certain lighting situations, the camera may botch the exposure, or you may just want the picture to look different. Metering modes allow you to change the way that the camera evaluates light or to actually second-guess that evaluation.

✔ **Spotmeter mode:** This mode (see Figure 2-13) sets the camera's light meter so that it reads just a small area of

the scene, rather than the whole thing. The area is almost always in the centre of the viewfinder frame, often indicated with a circle surrounding the central focus point. After you set the camera to spotmeter mode, you place the spotmeter circle over the area you choose — usually the most important part of the scene — and press the shutter button halfway to lock in the exposure settings. Then you frame up your final composition and press the shutter button all the way to take the picture.

Figure 2-13: Typical icons for spotmeter mode.

✔ **Manual backlight compensation mode:** Some point-and-shoots automatically compensate for backlight by increasing the exposure. But this mode (see Figure 2-14), found on a fair number of point-and-shoots, allows you to make sure that this compensating is happening. By selecting this mode, you make the camera add a certain amount of exposure, almost always 150 percent more, which is expressed photographically as +1.5 EV.

Figure 2-14: Typical icons for manual backlight compensation mode.

Creative modes

Modes can't really be creative — you're the creative one, right? But when you're feeling inspired, creative modes let you play with exposure, flash, or focus for unusual, arty, or just plain far-out effects. The effects are quite tasty, but a steady diet can lead to pictorial indigestion.

✔ **Bulb mode:** Named after the old-time air-bulb cables with which photographers of the past often snapped their shutters, this mode (see Figure 2-15) opens the shutter after you press the shutter button and keeps it open for as long as you bear down. It closes the shutter only after you let up on the shutter button. Bulb mode lets you take time exposures of 10 seconds, 10 minutes, or more. Use print film, which forgives exposure errors.

Figure 2-15: Typical icons for bulb mode.

A *time exposure* is a picture made with the shutter kept open deliberately for a long time — usually more than one second. Long exposure times allow non-flash photography of a very dark scene or create interesting streaky effects with moving objects.

✔ **Multiple exposure mode:** In a way, this feature (see Figure 2-16) can also be called a drive mode. It stops film from advancing so that you can deliberately expose one frame of film with two or more different scenes. Depending on your tastes, you may like what you get — somebody's face hovering in the sky, or your wife standing on two sides of the same tree. And depending on your eye, you can plan the exposures so that they work together.

Figure 2-16: Typical icons for multiple exposure mode.

If multiple exposure sounds dicey, you're right. All cameras that have it immediately default back to the previous mode after you've made two exposures, which, as you may guess, is called a *double exposure.* However, most models let you take still more exposures on the same frame, as long as you keep resetting the multiple-exposure mode.

Chapter 3

Optical Options: Seeing through Your Camera

You've probably noticed that when people ask to see your camera, the first thing they do is look through the viewfinder — not *at* the camera. It's a reflex. They seem to understand that the viewfinder is your window on a world of photographic possibilities, and far more important than any button or dial on the camera.

Within this window's frame, of course, is where you arrange your pictures. However it's indicated, the viewfinder frame has but one purpose: to show you what part of a scene your camera's lens will put on film when you press the shutter button. Of course, you're the one who really determines what the lens puts on the film, by looking through the viewfinder and moving yourself and the camera, and, in some cases, by zooming the lens. This process, and its result, is called *composition.* But before you can even think about composition, you have to understand just what the viewfinder and the lens do, and that's what this chapter, and the next, are all about.

Changing the Picture

You can change the view through your point-and-shoot's viewfinder window in a variety of ways. Move closer to something, and that object gets bigger in the viewfinder. Move back, and the object gets smaller. The object's appearance also changes when you tilt the camera up or down from a low or high position, which of course requires a little squatting or scrambling. But if you have a *zoom lens* on your point-and-shoot, you can change the view through the viewfinder window in another way — without moving at all.

Most zoom point-and-shoots' zoom controls take the form of a rocker or toggle switch, usually on the camera back behind the shutter button. But some models have two buttons on either side of the camera top; you press one and the other alternately with your shutter-button finger to adjust the zoom.

No matter the shape or form of your zoom control, rocking or sliding or pressing or wiggling it causes the lens to extend or retract, most often by way of telescoping tubes. If you look through the viewfinder window while you're adjusting the control, you can see that the view changes: Things seem to get closer or farther away, depending on which way you move the zoom switch or which button you press.

Adjusting a zoom lens to make things look bigger in the viewfinder is called *zooming in,* because its effect is something like physically moving in toward the subject. Adjusting a zoom lens to make things look smaller in the viewfinder is called *zooming out,* because its effect is something like physically moving out, away from the subject.

What's confusing is that when you zoom in, the lens actually extends farther *out.* And when you zoom out, the lens pulls back *in,* retracting toward the camera body. One suggestion: When zooming in and out, ignore what the *lens* is doing and pay attention to your *viewfinder.*

Going to Great Lengths

On zoom point-and-shoots, your viewfinder window is really just like a small, second zoom lens. When you zoom your camera's lens in or out, the viewfinder zooms right along with

it, showing you what the lens sees at every zoom setting. And here's the good part: You can take a picture at any of those settings — all the way out, all the way in, or anywhere in between. These settings are called *focal lengths.*

Focal length is a number used to describe both a lens's *magnification* (how big or small it makes the subject) and its *angle of view* (how much or how little of the scene it puts on film), two closely related photographic properties. The number is always followed by *mm,* which stands for millimetres.

A short focal length — say, 38mm on your zoom point-and-shoot — reduces magnification, giving the lens a wider angle of view. In other words, by making everything in the scene smaller, it puts more of it on film (similar to looking through the peephole on a door).

A long focal length — say, 105mm — increases magnification, giving the lens a narrower angle of view. In other words, by making everything in the scene bigger, a long focal length can't fit as much of the scene on film (similar to looking through a telescope or binoculars). Keep in mind, though, that focal length numbers can mean different things depending on what kind of camera you have — 35mm, Advanced Photo System (APS), or digital.

Don't confuse focal length numbers (which are always followed by mm) with the 35mm film format used by most point-and-shoot cameras. When a camera is said to be a 35mm model (as opposed to an APS or digital model), 35mm refers to the width of the strip of film in the standard cassette that it's designed to accept. When a camera is said to have a 35mm lens or a 35–70mm zoom lens, 35mm refers to the lens's focal length. Focal lengths come in all different numbers; 35mm is just one of them, but the main source of this confusion.

Even non-zoom point-and-shoots have a focal length — one focal length. For this reason, they get the gee-whiz name of *single-focal-length* models. This term is just a fancy way of describing what is, in camera terms, the plain-vanilla version. If you want, you can call a zoom model a multiple-focal-length or a variable focal-length camera. But you don't have to, because that jazzy little word *zoom* says it all.

An important note to folks with non-zoom, single-focal-length point-and-shoot cameras: There's no need for zoom-lens envy!

A zoom is a great tool for picture taking. But you can vary your lens's view enormously with a single-focal-length camera. You just have to use that most valuable of photographic accessories, your feet.

Going Wide — and Long

Once upon a time, if you wanted to change the angle of view of your camera's lens, you had to have a camera with interchangeable lenses, twisting off one lens and replacing it with another with a different angle of view. Many a good picture was lost making the switch.

The zoom lens put an end to that struggle. More than a convenience that lets you change your angle of view without changing lenses, it also lets you fine-tune your focal length. With a 38–90mm zoom, common on 35mm point-and-shoots, you can zoom to, and take pictures at, 38mm and 90mm, of course. But you can also shoot at 45mm or 70mm or any other intermediate setting. And these multiple settings help you not only fit the subject in the frame but also quickly tweak composition when you can't take the time to move in and out.

A zoom lens is described by its *focal length range,* an indication of its shortest and longest focal length settings. A 38–90mm zoom point-and-shoot has a focal length range of 38–90mm.

Keep in mind that when you turn on a zoom camera, its lens starts out just like the lens on a single-focal-length camera. It has the same, or similar, focal length setting — perhaps 35mm or 38mm for 35mm cameras — as a single-focal-length model's single focal length.

Smart thinking is at work here. This moderate wide-angle setting is extremely useful for most pictures you take. You can take pretty close shots with it; you can step back a bit and still get all of a nice big landscape in the picture. It's a fine focal length for group shots and grab shots. It works as well on vacations as around the house.

A moderate wide-angle setting, however, doesn't serve every purpose. If you want to fill the frame with a subject, you have to be physically pretty close. (Use those feet of yours, and walk right up.) Moving in close is no problem if photographing

blossoms in your backyard garden. People, on the other hand, aren't so thrilled with a camera inches from their nose, especially if they're crocheting a sweater or changing spark plugs. What's more, the picture you get when you photograph someone that close will more than likely be unflattering.

This sort of situation is when zooms are so useful. Fine, you're thinking, but how do I know when to zoom the zoom? Do I just zoom back and forth until the subject looks right?

Well, some focal length settings are better for certain kinds of pictures. You'll begin to understand which focal lengths to use for certain subjects as you shoot more pictures with a zoom point-and-shoot. Choosing an appropriate focal length quickly becomes second nature.

The easiest way to understand focal length numbers is to break them up into three categories: wide-angle, normal, and telephoto.

- ✔ Wide-angle focal lengths are the smaller numbers.
- ✔ Normal focal lengths are the in-between numbers.
- ✔ Telephoto focal lengths are the numbers that are bigger still.

With 35mm point-and-shoots, for example, the widest focal length available is 28mm, the longest telephoto, 200mm. (This range is different for APS and digital models.) Wide-angle, normal, and telephoto focal lengths each take a different view of things (see Figure 3-1). Here's the long and short of it.

The whole wide world

Any fan of *National Geographic* has seen photos like these: a white-water raft and its struggling crew against a background of towering Grand Canyon cliffs; the interior of a huge cathedral, from nave to chapel; a window view of a teeming street. These pictures are what you can get with a short focal length, or wide-angle focal length.

A wide-angle focal length lets you take pictures when you're short on space — when backing up any further is impossible because you're against a wall, on the edge of a cliff, or actually in that raft on the Colorado River. Thinking of these lenses as

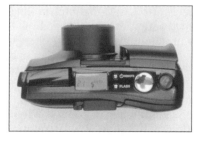

Lens set to 38mm

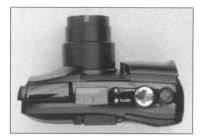

Lens set to 70mm

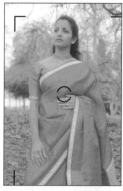

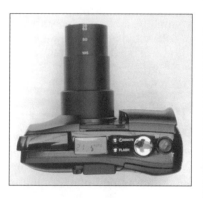

Lens set to 105mm

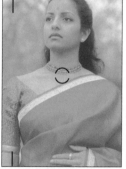

© Mark Harris (3)

Figure 3-1: When you turn on your point-and-shoot (here, a 38–105mm model), the lens automatically sets its shortest focal length (38mm) to provide the widest view of your subject (top). Zoom the lens to 70mm, and you get a tighter shot, as if you'd moved closer (centre). Zoom to 105mm, and the framing is tighter still (bottom).

reducing lenses may help, because they make things look smaller, and you can therefore squeeze more stuff into the picture. The shorter the focal length, the more the lens squeezes into the picture; a 28mm focal length on a 35mm camera squeezes in much more than a 38mm, just as a 24mm focal length on an APS camera squeezes in much more than a 30mm.

The normal view

As you zoom your point-and-shoot's lens to slightly longer focal lengths, you get into the *normal* range — on 35mm models, about 45mm to 55mm, and on APS models, 35mm to 45mm. Normal focal lengths give you the most natural-looking rendition of the subject. Pictures taken at normal focal lengths appear neither magnified nor reduced. They neither exaggerate depth, like a wide-angle focal length, nor flatten the scene, as happens with telephoto focal lengths. And precisely because normal focal lengths give you no visual gimmicks to fall back on, you have to work especially hard with what's inside the viewfinder frame. You have to arrange the elements of the picture in an interesting way, or wait for the telling gesture, or take the shot in just the right light.

Many point-and-shooters, though, have the habit of using their zoom lenses at only two settings — zoomed all the way out and zoomed all the way in. They completely ignore the focal lengths in between, which include the normal range.

The telephoto touch

Long focal length settings — those beyond 60mm on a 35mm point-and-shoot, or 50mm on an Advanced Photo System model — are also known as *telephoto* focal lengths. You use them when you need to capture a subject that's at a distance, either because you can't get closer or because getting closer would call too much attention to your photographic intentions. Telephoto focal lengths magnify the subject. The longer the focal length, the greater the magnification.

When you zoom in with your camera, you're simply changing the focal length to a telephoto setting. But more is going on than simple magnification. Telephoto lenses tend to *flatten* or *compress* a scene.

This flattening effect makes moderate telephoto focal lengths —
those from about 70mm to 100mm with a 35mm zoom
point-and-shoot, and from 55mm to 80mm with an APS model —
highly prized for portraits. Because you can fill the frame with
a face without getting physically all that close (arm's length or
better), you don't get big noses or bug eyes or jutting jaws.
Focal lengths from 70mm to 100mm with 35mm, and from
55mm to 80mm with the Advanced Photo System, are often
described as *portrait telephoto,* for the flattering proportions
that they bring to tight shots of people.

Here is one last note on zoom point-and-shoots that offer longer
focal length settings. At these settings, the lens aperture gets
much smaller, which means that less light reaches the film.
The camera may try several things to make up for this lack of
light. It may fire the flash, which you may not want — or if the
subject is too far away, may not help. Or the camera may set a
much slower shutter speed increasing the risk that a shake
will blur the picture.

Even though certain focal lengths are good for certain picture-
taking situations, no photographic law exists that says you
have to follow the focal length rules all the time. Just for the
fun of it, zoom to another setting and try a picture there.
Wide-angle close-ups of kids' faces, in particular, can make for
zany shots — even though they are, technically, taken at the
"wrong" focal length for portraits.

Chapter 4

Focusing

• •

• •

*F*ocusing was the last great hurdle of camera automation. Automatic film advance, automatic flash, and automatic exposure have long been a fact of point-and-shoot life. Automatic focusing — *autofocus,* for short — is a more recent innovation, relieving one of the great anxieties of snapshot photography. Autofocus has saved many pictures that otherwise would have been lost to old-fashioned manual focusing.

A point-and-shoot will take a good number of sharp pictures if you just glance through it and snap away. Left to its own devices, your camera will, indeed, focus automatically on whatever chance places in its path. But you simply can't leave focusing to chance. That's how bad pictures happen to good people. Autofocus is really a misnomer. Power-assisted focus, or maybe computer-aided focus, would be more accurate. Autofocus cameras simply help *you* focus the lens.

Autofocus versus Fixed Focus

Autofocus is not a necessity for good pictures. Many less expensive point-and-shoots, and *all* one-time-use cameras, rely on *focus-free* operation. This term should really be *fixed focus,* as the lens's focus is permanently set. This fixed setting

gives you pretty sharp pictures if your subject is at an average snapshot distance (eight feet or so), and less-sharp-but-acceptable pictures if your subject is a little closer or farther away. But if you're too close, your print will not appear sharp. With fixed-focus cameras, four feet is about as close as you can get for reasonably sharp snapshots; anything closer may appear blurry. Check your manual for the minimum distance recommended.

The best way to tell whether you have an autofocus or a fixed-focus point-and-shoot is to look through the viewfinder. Autofocus models have a small set of marks — often in brackets or in a cross shape — in the center of the frame. These marks, called the *focus point,* tell you where the camera is focusing. If you have a fixed-focus point-and-shoot, its viewfinder lacks the focus point (see Figure 4-1).

Figure 4-1: An autofocus point-and-shoot's viewfinder has a central focus point (left); a fixed-focus model has none (right).

A fixed-focus camera also lacks the green *focus-OK lamp* found on autofocus models. (See "Making sure your focus is locked," later in this chapter.) The lamp is usually built into the side of the viewfinder eyepiece or is just inside the eyepiece frame, where you can see it out of the corner of your eye when looking through the viewfinder. (Fixed-focus models often have a flash-ready lamp, usually red.)

The Focus Point: Where Your Camera Focuses

Autofocus point-and-shoots produce terrifically sharp pictures when used properly. But getting sharp results sometimes requires *telling* them where to focus. The camera automatically focuses on whatever part of your subject the focus point is

What is autofocusing?

Focusing is the process of moving the lens in and out to form the sharpest possible image of a subject on film. For every subject at a different distance from the camera, the lens must be at a different distance from the film to create the sharpest possible image. Autofocus point-and-shoot uses technology to measure the distance to a subject, relaying this information to a motor in the lens. The motor then moves the lens to the proper distance from the film.

When you look through an autofocus point-and-shoot's viewfinder window, though, you don't see the focusing process, even though it's happening inside the camera. The entire scene remains sharp regardless of where the lens actually focuses. For most people, this fact isn't bothersome.

covering when you press the shutter button. If you're photographing a friend who is six feet away, and the focus point covers the friend's face, your camera autofocuses six feet away. If you're photographing mountains that are a mile away, and the focus point covers them, the camera autofocuses, well, way out there. (Beyond a certain distance, everything is sharp anyway.)

You can't assume that the focus point will always fall in the right place. Imagine photographing two friends standing six feet away from you with mountains in the background. Your friends are smack in the middle of the viewfinder frame. But between the two of them is a little gap, and the focus point falls neatly into it — covering a little piece of distant mountain. Not noticing this gap, you point and shoot, and the camera focuses on the mountains, not your friends.

Unintentional focusing on the background is, along with unwanted camera movement, the main cause of point-and-shoot pictures that aren't sharp. A simple way to avoid this — a photographic one-two punch — is *locking the focus,* the only sure way of getting the camera to focus on the most important thing in your picture.

Locking the focus

You should lock the focus any time your composition does not place the focus point on the most important part of what

you're shooting. By locking the focus, you deliberately make your camera focus on an important object in the scene and keep the focus locked at that exact distance until you take the picture. Here's how you lock the focus:

1. **Look through the viewfinder and position its focus point on your main subject.**

 In effect, you centre that subject.

2. **Press the shutter button halfway down, until the green focus-OK lamp in the viewfinder eyepiece glows steadily.**

3. **Holding the shutter button halfway down, move the camera so that your desired composition appears in the viewfinder.**

4. **Press the shutter button all the way down to take the picture.**

 Figure 4-2 shows an example of locking the focus.

You can also use this technique with vertical composition, for example, to shoot a vertical picture in which your friends are at the bottom of the viewfinder and the mountains in the background are at the top. Your composition has the focus point covering the mountains, not your friends. So first aim the camera down to place the focus point over a friend's face (temporarily cutting off the mountains at the top) and press the shutter button halfway. Then, holding the shutter button halfway down, you swing the camera back up to re-establish your composition before fully pressing the shutter button to take the picture.

You may wonder what happens to distant objects when you lock the focus on closer objects. "If I focus on my friends in front of the mountains," you ask, "then won't the mountains be out of focus?" Good question. Here's the important answer.

With most scenes in which you photograph a relatively close object (human or inanimate) in front of a distant background, if you focus on the close object, the background will be reasonably sharp in the print. But the reverse is not true. Focus on the background — those mountains — and the close object simply won't be sharp.

Figure 4-2: For a shot with an off-centre subject (top), first centre the subject and lock the focus (centre) and then pivot your camera to your desired composition (bottom) before completing your shot.

Making sure your focus is locked

When you lock your focus, you can't actually see the subject getting sharp in the viewfinder. However, you can verify that your point-and-shoot has autofocused on something by looking at its *focus-OK lamp.*

The focus-OK lamp lights whenever you press the shutter button halfway. If it glows steadily, the camera has successfully focused. If the focus-OK lamp blinks, doesn't light, or lights briefly but then goes out or starts blinking, it's telling you that the camera can't focus.

Usually, your camera can't focus because you're too close to the subject. Fix the problem by easing up on the shutter button, stepping back a foot or two, and then pressing the shutter button again. If this tactic doesn't do the job, the autofocus system may be getting tripped up by a difficult subject.

If you move, the focus doesn't

Locking the focus is vitally important to getting consistently sharp pictures. But you should remember that when you have that shutter button pressed halfway, the focus doesn't budge. If you ask your subject to move closer or farther away, or you move closer or farther from your subject, it's no longer in focus. If the distance to your subject changes after you've locked the focus, you must let up on the shutter button and repeat the focus-locking procedure.

Zoom before you lock the focus. With most point-and-shoot cameras, locking the focus also prevents you from adjusting the zoom. If you want to zoom in or out after locking the focus, let up on the shutter button, adjust the zoom, and then lock the focus again.

Widening the Autofocus Horizon

To lessen the chance that your camera accidentally focuses on a background rather than your main subject, point-and-shoot manufacturers have come up with a clever technology called *wide-area autofocus,* also known as *multibeam* or *multipoint autofocus.*

Focusing through a window

A window may look transparent, but most point-and-shoots see it as solid. They focus on the glass, rather than what's on the other side of it. The solution to this problem is to use your camera's *infinity lock* mode. This mode, sometimes called *landscape mode,* works best with subjects that are far away. When you set the camera to infinity lock, it basically overrides the camera's autofocus, setting the lens to focus as far away as it can.

To make sure that you get correct focus when shooting through a window, the best strategy is to open the window. If this is impossible — or moving your prize African violets from the windowsill would take too long — use infinity lock, if your camera has the feature. If not, try putting the camera right up to the glass to shoot — though I suggest testing this method before a picture opportunity happens.

Generally, wide-area autofocus is sensitive to the central one-quarter to one-third of the horizontal picture frame. This extra spread allows the camera to correctly focus subjects that are a little off-centre. If, for example, the camera detects more than one thing in the focusing area (for example, two friends), it focuses on what's closest to the camera. If your two friends are an equal distance from the camera, it will focus on them, not what's behind them, a feature well suited to *grab shots,* where you have just enough time to turn on the camera and snap.

But focusing mistakes are still possible with wide-area autofocus. A subject may be a little too far to the side for it to catch, so the camera focuses on something in the background anyway. And how do you know if it's screwing up? You don't. The green focus-OK lamp glows steadily as the camera has focused just fine on something far away.

So why take the chance? If you have the time — and you don't need much — always lock the focus, whether your camera has wide-area autofocus or not.

The Commandments of Good Autofocusing

You're getting off easy — this section has the three most important commandments, not the usual ten. Follow these three, and you'll get well-focused pictures almost all the time. To get the most from these tips, you need to know whether your camera has an active or passive autofocus system. *Active autofocus* bounces infrared beams off the subject so that the camera can determine the distance to it and set the lens's focus accordingly. *Passive autofocus* determines the subject's distance by analyzing the image itself and adjusting focus until subject details are as sharp as they can be.

Before you get flustered by these techie-sounding terms, here's a simple way to figure out which system your camera uses — in case you've lost your manual, which should tell you what you've got in the specifications section. Outside, in daylight, aim the focus point at a patch of open, featureless sky, no wire or clouds allowed. Press the shutter button halfway. If you get a blinking focus-OK lamp (meaning focus is not possible), you probably have passive autofocus. If you get a steady lamp (meaning focus is okay), you have active autofocus.

With all types of autofocus

Here are the three commandments of good autofocusing that should help you get sharp focus regardless of what kind of system you have.

- ✔ **Thou shalt lock the focus.** Locking the focus should be utterly reflexive. Don't count on multibeams or any other gizmo your camera may have.

- ✔ **Thou shalt watch thy focus-OK lamp.** The focus-OK lamp glows steadily if focus has been achieved and blinks if something is amiss. Quite a few cameras use different rates of blinking to tell you what's up: Fast blinking usually means the camera can't find the focus; slow blinking may mean you're in a special close-up range or that you're just too close.

> ✔ **Thou shalt use infinity lock, if thou hath it.** Even if you're pretty sure your camera can focus accurately at great distances, setting infinity lock is a good precaution when shooting far-away scenes — but only if there's no important foreground.

With active autofocus

When you lightly touch the shutter button of an active-autofocus camera, an infrared beam shoots out of a small window on the camera's front. (Infrared is the same invisible light that allows a remote control to operate your TV.) This beam is reflected back to the camera by solid objects, just like visible light. A window on the front of the camera senses this bounced-back beam, and the camera calculates the angle at which it bounced off the object, computing how far away an object is and setting the lens to focus at that distance.

Active autofocus has some great *advantages,* which is why you can find it on the vast majority of point-and-shoots:

> ✔ Active autofocus works in the dark — even pitch black. So it's great for party pictures in dim basement rec rooms.
>
> ✔ You don't have to aim a camera with active autofocus at a detail in the subject. It can focus on a blank wall just as well as it can on Uncle Clive's plaid leisure suit — and do so very quickly.

And you know active autofocus is bound to have drawbacks, right? Ironically, the biggest of these is that active autofocus can focus just about anything. It's indiscriminate, which leads off its *disadvantages:*

> ✔ Active autofocus can focus right past a subject that isn't in the middle of the frame. If Uncle Clive is standing off to the side and you don't first lock the focus on him, your single-minded little robot focuses on the wall behind him.
>
> ✔ Active autofocus doesn't have a very long range. The infrared beam can't accurately figure the distance to the subject if it's more than about 25 feet away. The limited range usually isn't a problem except with longer zoom lenses, which need to be focused more precisely at far distances.

With passive autofocus

To overcome some of the drawbacks of active autofocus, some higher-priced point-and-shoots have passive autofocus. Passive autofocus works something like your eyes, analyzing what's in plain view. When things are in focus, you can easily tell the difference between light and dark details; when things are out of focus, light and dark areas tend to blend together into gray. Passive autofocus moves the lens until it finds the point at which contrast is greatest — or where Uncle Clive's plaid leisure suit has the most snap to it.

Passive autofocus has some nice *advantages:*

- Passive autofocus is not limited in distance. It can focus two miles away as easily as two feet away because it doesn't depend on a wimpy infrared beam. That's why you most often find passive autofocus on point-and-shoots with long zooms.

- Passive autofocus can focus through glass because it sees through the window to objects on the other side.

Indeed, passive autofocus's single great advantage is that it's particular, unlike that unfussy slob active autofocus. If you aim your focus point at the blank wall behind Uncle Clive and Great Aunt Gretyl, passive autofocus blinks a warning lamp or balks outright, one of the *disadvantages* of passive autofocus:

- Passive autofocus can't focus on areas without detail.

- Passive autofocus can't focus in the dark because it doesn't have enough light to see — and it can be slow even when it does.

Chapter 5

A Flash of Inspiration

. .

. .

*I*n flash photography, there *were* no good old days. Though it may be smaller than a postage stamp, your camera's built-in electronic flash just keeps going and going, letting you shoot as many pictures as your film and batteries allow. And when it comes to improving the quality of your photography, your flash is a far more helpful and sophisticated device than the blinding bulbs and rotating cubes of yore.

Yet all the innovation in this itsy-bitsy, teeny-weeny marvel simplifies taking pictures with flash. Your camera's flash system fully automates — with remarkable dependability — the once mind-numbing exposure calculations that made getting flash pictures such a gamble.

Autoflash: No-Fault Photo Insurance

Whether they pop up, slide out, or just stay put when you turn on the camera (see Figure 5-1), most built-in flash units fire *automatically* when the camera senses that your subject doesn't have enough light for a good exposure. This isn't to suggest that you have no creative control. Unless your camera is a

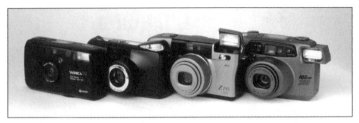

Figure 5-1: Some built-in flash units pop out when you turn on the camera, but most just stay put.

very basic model, you have up to five or six flash modes at your command.

Most point-and-shoots offer at least three flash modes — *autoflash, fill-flash,* and *flash-off.* Many cameras also offer *slow-sync* and *red-eye reduction* flash. These modes make your flash the single most important creative tool on your point-and-shoot. But if at first you feel intimidated by the choices — or if your camera offers a limited number of flash modes — remember that left to its own devices, your camera's thoroughly modern flash will fire whenever it's needed.

When you turn on your camera, it immediately sets itself to autoflash mode. Suppose that you're shooting the kids and dog running through the sprinkler on a bright July day. Your camera's lightmetering system sees all that sun and tells the flash it's not needed. So the flash doesn't fire. Follow the inevitable trail of mud into the house, though, and the camera detects dimmer light, automatically triggering the flash.

With fast-moving subjects in fast-changing conditions (did someone say kids and dogs?), don't worry about setting flash modes. Indoors or out, just turn on the camera and shoot.

Autoflash is no-fault photo insurance, just what you need when you don't want to fiddle with the camera while your kids trash the new carpeting. With it you're almost guaranteed a sharp, colourful, well-detailed picture. But here's the surprise: *Sometimes you should use flash in bright outdoor light. And other times you should turn the flash off in dim light.* Stay tuned; this chapter fills you in.

Button, Button, Where Is the Button?

To make the flash fire outdoors or not fire indoors — or to make it do other interesting things — push the flash mode button. This button is usually marked with a lightning bolt. Repeatedly pushing this button *toggles* through the flash mode icons, which are displayed on the camera's LCD panel. Get out your camera and try this. If getting out your camera inspires you to take some pictures and you can't figure out how to get back to autoflash, with nearly all point-and-shoots, simply turning the camera off and on again resets it to autoflash.

If the flash mode button isn't on top of the camera, look for it under a flap or on the back or sides. Different models set and indicate flash modes in different ways. With some models, pushing the flash mode button moves a pointer along printed icons adjacent to the LCD panel. With others, you have to rotate a thumbwheel to select the mode that you want. Sliding switches are another, though less common, type of control. Check your manual. (See Figure 5-2.)

Figure 5-2: The way you change flash modes depends on your particular point-and-shoot.

Whatever you push or rotate to choose a flash mode, let the icons be your guide. And keep in mind that your particular camera may display no icon at all when it's in autoflash mode, your camera's way of telling you it will take care of things. On some models, the LCD panel displays the actual word *auto,* often paired with a lightning bolt. So if you've taken the camera out of its autoflash mode, you can get it back simply by pushing the button repeatedly until auto reappears — or the flash icon disappears altogether.

Flash to Fill Shadows

With many point-and-shoots, the first push of the flash mode button causes a plain lightning bolt to appear on the LCD panel. If your camera displays a lightning bolt (and auto) in its auto-flash mode, this first push may cause the word to disappear, leaving just the bolt. Sometimes the lightning bolt is paired with the words *fill, fill-in,* or just plain *on.* And sometimes it appears with a graphic of the sun.

Some point-and-shoot models call this mode *fill-in flash,* both on the LCD panel and in their manuals. Others use names like *flash-on, anytime flash,* or my personal favorite, *forced emission.* All mean the same thing: The flash fires every time you take a picture.

Why would you want flash when the subject is bright already? To *fill* unwanted shadows with light. High sun in particular creates unattractive hollows under facial features.

Fill flash is as much a no-brainer as autoflash, and no less automatic in its operation, pumping out the right amount of light for the occasion. You have to select fill flash with the flash mode button, of course. But once you do, you can leave fill flash on; even indoors, it does the job.

How do you get fill flash if your point-and-shoot doesn't have an LCD panel with which to display the fill-flash icon? Even cameras with few controls often have a fill-flash button, usually marked with a lightning bolt. But to get fill flash, you must hold down this button *as you're taking the picture.* (It's usually on the side of the camera opposite the shutter button, so you can push it with the fingers of your left hand.)

Fill flash compensates for the inability of film to capture good detail in both the brightest and the darkest parts of some subjects. Though fill flash adds the same amount of light to both highlight and shadow areas, the extra light is more visible in the shadows because shadows are less bright to begin with. This effect actually reduces *contrast* — the difference between the scene's lightest and darkest parts — keeping it within the range of brightnesses the film can record.

When to use fill flash

Fill flash is a perfect remedy for the small, scattered shadows that can make portraits taken in direct sun so ghastly. Fill flash lightens the eye sockets and nose shadows that would otherwise end up as black as the black hole of Calcutta (see Figure 5-3). It can turn a guaranteed failure into a flattering portrait. Fill flash is mainly an outdoor flash mode, but it also helps with sun coming through a window.

Figure 5-3: Fill flash lightens the harsh shadows produced by direct sun (left) for a more pleasing portrait (right).

In addition to retrieving eyes from their sockets, fill flash adds *catchlights* to them. Catchlights are tiny, pinpoint reflections of a light source — in this case, the flash as it fires. Without catchlights, a subject's eyes can look dull and lifeless. Any good studio portrait has catchlights created deliberately by the photographer.

 When shooting outdoors in daylight, leave the camera set to fill flash. Move from sun to shade and back as you shoot and be pleasantly surprised at the consistency of the results. If you turn the camera off between shots, remember to reset it to fill flash when you turn it on.

Fill flash is also made to order when the main subject is in shadow against a much brighter background. By flashing your subject, you lessen the difference in brightness between the foreground (your subject) and the unshaded area in the background. Fill flash makes the foreground and background appear more balanced.

When the background is much brighter than the main subject or the light is coming from behind the subject, the subject is *backlit*. Some point-and-shoots can, in autoflash mode, sense that difference and fire the flash to compensate for it. These models automatically fire the flash though the overall light is bright — a condition that causes most other models to turn the flash off when in autoflash mode.

This feature is usually called *automatic backlight compensation.* A sort of automatic fill flash, it usually doesn't work with a subject in scattered shadows. So don't use it as a substitute for setting fill flash.

When not to use fill flash

At times, fill flash won't have much effect and may do more harm than good. For example, fill flash won't have much effect if your subject is too far away for the flash to "reach." Fill flash won't fill the shadows in a big landscape, for example.

All that said, you can maximize your fill flash by staying as close to the subject as practical. If your camera is a zooming model, avoid longer focal length settings, which force you to move farther from the subject to fit it all in the frame. Instead, zoom to the shortest focal length setting that the subject permits. A shorter focal length lets you get closer but still fit everything in the frame.

Always keep fresh batteries on hand. Heavy flash use reduces the number of rolls a battery can power through your camera.

Flash-Off Mode: To Flash or Not to Flash

If you're a sports fan, you've probably noticed that big plays at night games ignite a thousand points of flash in the grandstand. Professional photographers joke about the phenomenon; most of those pictures won't come out. There's just no way a small flash can light a stadium.

Alas, your point-and-shoot has no way of knowing that the subject is too far away to light. It just sees the lack of adequate

How far will your flash reach?

Built-in flash units vary in power, affecting the distance range within which they can adequately light a subject. Check your manual's specifications section to find out your point-and-shoot's flash range. Many of the indoor photos that you take will fall within your flash range, especially if you use fast films. Another way to increase your camera's flash range is by zooming to a shorter (wide-angle) focal length. This setting not only allows you to shorten the distance between you and your subject but also causes the camera to set a bigger lens aperture. And the bigger aperture lets the camera gather more light from the flash.

illumination and flashes blithely away. It pumps out every particle of light it can muster, overexposing the heads of the people in front of you and turning them into hairless wonders. Distant sports action ends up darker than the mood of a losing quarterback.

What to do? Just turn the flash off. Press the flash mode button until the LCD panel shows a lightning bolt slashed through by the universal "no" symbol — a circle around a diagonal line. On some models, the cancelled bolt may also be accompanied by a moon or star symbol. On a few models, you may get no bolt, only the moon and/or star. Whatever the icon, the idea is that you're turning the flash off in dim light, light that would otherwise cause it to fire automatically.

Your manual probably calls this mode *flash-off.* By turning the flash off, you force the camera to take the picture by the existing artificial illumination of the stadium itself.

I don't mean to suggest that sporting events are the only occasions on which to turn off your flash. Here are some other occasions when you should consider setting the flash-off mode.

- ✔ **When you're shooting far-away subjects that would otherwise automatically trigger the flash.** A landscape at dusk would be a good example.

- ✔ **When the quality of light is an essential part of the picture that you want to create.** Say that you're photographing the play of late-afternoon sun across rippling

sand. You get in close, for an abstract effect. The light may be low enough to activate the flash in autoflash mode, especially if you're using an ISO 100 film. And flash will probably ruin such a shot by lightening the shadows — both big shadows cast by ripples and tiny ones cast by grains of sand — that provide its eye-catching sense of texture. Interesting, angular, atmospheric light is often low light, and low light is the flash's cue.

✓ **When you're shooting through a window.** If you don't turn the flash off, the reflection of the flash may obscure or obliterate your subject. You can eliminate the reflection by pressing the camera right up to the glass as you shoot. Be warned, though, that doing this may cause the camera to focus incorrectly. If your camera can focus correctly, you're in luck. If your camera doesn't focus correctly, try wiping off a clean patch on the window. Better yet, just open the window.

Keep in mind that turning your flash off introduces complications. If you're shooting in a dimly lit stadium, especially with slower film (ISO 100 or 200), the camera may set slower shutter speeds to make up for the inadequate light. With some models, such speeds may be a second or more, making freezing a moving subject difficult. But just as significant, slower shutter speeds increase the likelihood that hand tremors (which you don't even notice) will blur the image.

Red-Eye Reduction: Getting the Red Out

Yes, your kids can be devils. But that's not why they sometimes have glowing red eyes in your flash pictures. Point-and-shoot cameras are especially susceptible to a photographic affliction called, matter-of-factly, red-eye. Red-eye is the price of a point-and-shoot's compactness: Its flash is so close to the lens that it actually reflects off your kids' (or others') *retinas,* the backs of their beady little eyes. Red-eye is unpredictable, but it's more likely to occur with blue-eyed people in dark environments.

Red-eye is a particular problem in dim light, which automatically triggers your camera's flash. In dim light, your subject's pupils dilate, uncovering more retinal surface — and a larger area to reflect the flash. Whether your camera uses preflashes

or a prelamp to reduce red-eye, the idea is the same: Throw light into the subject's eyes, and his, her, or its pupils immediately contract, lessening the retinal area exposed to the final, full flash.

To lessen this effect, manufacturers have put red-eye reduction flash capability into all but their most basic point-and-shoots. Alas, these red-eye reduction systems can create more problems than they solve, so this section explains some ways of circumventing the problems.

Red-eye reduction comes in two varieties:

- ✓ **Preflash type:** The most common type of red-eye reduction system, the camera emits one or more low-power flash bursts before the final, full-power burst with which it takes the picture.

- ✓ **Prelamp type:** The camera shines a small white or red lamp at the subject for a second or so before the exposure.

Built-in red-eye reduction may make you miss important pictures, especially true of the preflash variety. So consider your own, personal red-eye reduction system: Take a Sharpie — one of those marks-on-anything pens — and blot out any offending red eyes. Or you can ask your friendly neighbourhood photo dealer for a red-eye-retouching pen, which neutralizes the unwanted red instead of simply covering it, preserving a semblance of natural eye colour.

Preflash red-eye reduction systems

Red-eye reduction systems that work by preflash(es) can cause two problems.

- ✓ First, your subject may mistake the preflash(es) for the actual picture, and look or turn away, ruining the shot, of course.

- ✓ Second, even if you tell your subject to expect the preflash(es), he may not know what to do during the lag between preflash(es) and final flash. In that seemingly interminable time, the lively moment you sought to capture when you pressed the shutter button can turn into an awkward, self-conscious stare.

Watching the perfect picture slip away as your camera puts on a light show is frustrating, to say the least. Some red-eye reduction preflash systems fire a rapid and very distracting series of up to ten or so bursts before they take the picture.

 Particularly if your red-eye reduction system is of the preflash sort, I suggest that you don't use it. As if to acknowledge the problem, some manufacturers relegate red-eye reduction to a separate button, so it's not part of the usual flash mode sequence. You can turn it off and on, or combine it with other flash modes, at your discretion. Thank you very much, but I'd rather have a good picture with red-eye (and fix it with a Sharpie, if need be) than a crummy picture without red-eye.

Prelamp red-eye reduction systems

Prelamp red-eye reduction systems are sometimes — and only somewhat — better than preflash systems. The little light may serve as an attention-getting birdie, but if it's bright, it may also make your subject squint. The light may delay the picture just as much as a preflash system does, as it needs to stay on for a second or so to have an iris-closing effect — and it doesn't have much of one even then. But at least people won't think you've taken the picture and turn away.

 To maximize the effect of prelamp red-eye reduction systems, have your subject look directly at the little light until the picture is taken.

If you're shopping for a new camera and red-eye reduction is important to you, try to find a model with a prelamp system, or a system in which other flash modes aren't saddled with red-eye reduction, so you have more control. And remember that no point-and-shoot red-eye reduction system always eliminates red-eye.

 To lessen red-eye without resorting to your camera's red-eye reduction setting, open the curtains, roll up the blinds, and/or turn on more room lights. Oh, and take more pictures of people *without having them look at the camera.* Such pictures may be more interesting anyway.

Chapter 6

The Light Fantastic

*L*ight is ever changing. It changes from minute to minute, hour to hour, month to month. It changes with the weather and with the season. Experienced photographers take advantage of those changes. They wait until the end of the day, for example, when the sun colours things red; or for night to pass, to shoot by the suffused light of dawn; or for a storm to leave colour-enhancing wetness or a blanket of snow in its wake; or for midwinter days, when a clear sky turns a weak sun's shadows blue. For great light in your pictures — something more than a good subject — you may have to wait. But you have to know what you're waiting for — the characteristics of the light you want — and how to modify them, which is what this chapter covers.

How Light Creates Mood and Atmosphere

Realistically, most photographs that you take must be shot when you see them, not a minute later. These pictures — off-the-cuff shots of friends, family, and events — are of moments, and the light in them is secondary to the subject. When your sister attempts a handstand in the living room, you grab your camera as fast as you can and shoot. You don't stop to worry

about the light. In fact, in such situations your flash is probably doing most of the lighting anyway.

But some photographs — or photographic possibilities — are as much about light as they are about their subjects. Your husband may occupy the same easy chair every Sunday, but one day the light on him may seem different — a beam of warm sunlight raking across the side of his face, making the texture of his skin stand out.

Raking light is light that scrapes across a surface at a steep angle, making its texture stand out. Outdoors, it's especially noticeable at the beginning and end of the day, when the sun is low in the sky.

The light on your husband's face may, indeed, be something new: the effect of a change of season, a felled tree, curtains opened for the first time in weeks. Or maybe you just haven't noticed it before. That's the thing about light: You tend to take it for granted. And if you want to be a good photographer, you can't do that.

A good photographer studies light. Your apartment or house, your yard or neighbourhood, are perfect places to begin. Don't just look at objects; look at how the light describes them differently as it changes over the course of a day. The tree across the street may look delicate and ethereal by morning fog; pick up bold, angular contrasts within its branches as the weather clears and the sun gets higher; and then take on a rosy glow in the setting sun's last rays. Those changes illustrate the three overriding features of light: quality, direction, and colour.

The quality of light

Photographers like to describe light's quality in a tactile way: hard or soft. *Hard light* is direct from the source, undiffused. The sun on a clear day produces hard light; a bare lightbulb in your basement produces hard light. If you think of light as made up of individual rays, hard light's rays head straight for the subject from the light source.

A *light source* is where the light that directly illuminates your subject begins. In the case of the sun or a household bulb, the light source is the actual producer of the light; in the case of a window or a skylight, the light source directs the light.

Soft light, on the other hand, is scattered light. Instead of reaching the subject directly from the light source, its rays pass through things and bounce off surfaces to surround and envelop the subject. The light on an overcast day is soft, scattered by clouds; the light in open shade on a sunny day is soft, bounced in by the clear blue sky; the light from a ceiling full of office fluorescents is soft.

Shadows are your main visual clue to the quality of light. Hard light produces dark, hard-edged shadows. Soft light produces paler, soft-edged shadows, or none at all.

Manipulating hard light has but one purpose: to make it softer. Hard light is intriguing, but soft light is ideal for photography. Soft light is usually more flattering to both people and things. And it's much easier to work with, photographically, than hard light.

The direction of light

Within a given scene, some shadows are cast by the subject on adjacent things — Rover's shadow on the grass beneath him, for example. And some are cast by the subject on itself — the shadow of someone's nose on his cheek. The direction and/or angle of the light determines where those shadows fall. A low sun throws that nose shadow sideways, across the cheek; a high sun throws it down, toward the lips. A high sun throws Rover's shadow down, on the grass beneath him; a low sun throws the shadow sideways, across the grass. Light striking the subject from the side is *sidelight.* Light striking the subject from above is *toplight.* You're much more aware of light's direction with hard light than with soft, because hard light's shadows are more distinct. In fact, soft light with no shadows visible is often called *nondirectional* light.

The colour of light

If you've ever watched the pale yellows of a spring sunrise or the ruddy reds of a winter sunset, you know that light has a range of colour. With natural light, this variation has to do with weather and other atmospheric conditions. Early and late-day sunlight, because it strikes your patch of earth at a more glancing angle than at high noon, must pass through more atmosphere. And the more atmosphere it passes through, the

more airborne particles, dust, water vapour, and even pollution act as a sort of colour filter.

But that filtering effect extends to cloudy days, too. A layer of overcast, in addition to greatly softening sunlight, gives it a cool, sometimes bluish quality (more noticeable in prints than when you actually observe it). And the light in open shade on a clear day is bluer still because it's cast by an expanse of open sky. Foggy conditions can actually make a subject almost colourless, for an interesting monochromatic effect in your print.

Coping with Hard Light

A long-retired photographic adage held that to take pictures in direct sun, you should keep the sun over your shoulder — in other words, behind you, slightly above you, and to the side. The advice seems to suggest either that you take pictures only in one direction or that you move your subjects around, not caring much for the background.

Neither photographic subjects nor the sun are as cooperative as that old adage seems to assume. Usually, you can't move the things you want to photograph, and moving people can ruin spontaneity. Picture possibilities present themselves all the time, not just when the sun is over your shoulder. But that adage does have a kernel of photographic wisdom in it. Sun hitting a subject from roughly the same angle at which you're taking the picture (over your shoulder) minimizes the size and number of heavy shadows on it. This nearly frontal light is somewhat more flattering to human subjects than overhead sunlight, which creates heavy, unattractive shadows under noses and in eye sockets. In either case, hard sun tends to bleach out colour.

Shooting in direct sun

Picture opportunities, of course, rarely wait for ideal lighting conditions. And you don't always have the time to wait for better light either. But several simple, quick techniques can help you tone down harsh daylight: adding fill flash, increasing the exposure, and using reflectors. (See "Preserving detail in hard light" for more.)

Avoid letting sunlight or any direct light source (a floodlight, for example) strike the front surface of your lens when you take a picture. This causes stray light to bounce back and forth inside your lens, not only creating streaks and bands but also often fogging the entire image — giving it a washed-out appearance (see Figure 6-1). You will see sunlight striking the front of the camera through your viewfinder; the scene will appear washed out, with streaky reflections crossing through it. This ruinous effect is called *flare.*

© Peter Kolonia (2)

Figure 6-1: Shooting with the sun behind the subject may allow direct light to strike the lens surface, causing picture-fogging flare (left). To prevent this problem, shift your position to block out the sun and set fill-flash mode (right).

If you want to shoot toward the sun, position yourself so that a tree, roof, or other object outside the picture area blocks the sun, in effect shading the lens. Or hold the camera with only your right hand as you shoot, using your left hand to shade the lens. (Be careful not to get your hand in the picture.)

Preserving detail in hard light

The patterns created by hard sunlight can be unattractive or confusing. Perhaps the worst thing about hard light, though, is that in extreme cases, film may not be able to record detail — that is, tone and texture — in areas that are both directly

sunlit and are in shade. Even when film can record detail in both sunny and shady parts of a scene, the print that you get may contain only one or the other.

Highlights are the lightest and/or brightest parts of a subject — those sunny areas, for example. *Shadows* are the darkest or most shaded parts of the subject. You can also use these terms to describe the lightest and darkest parts of the print, and the difference is called *contrast.*

When you *look* at a subject with brilliant highlights and deep shadows, you're able to see detail in both areas. When you gaze at the highlights, the lens aperture in your eyes — that is, your pupils — gets smaller. But the instant your gaze shifts to the shadows, your pupils open wider to let in more light. Unlike a point-and-shoot camera, which must choose one and only one aperture for a picture, your pupils change their size continuously as you scan a scene. What's more, in lower light, the "film speed" of your retinas (the light-sensitive back of the eye) is, in effect, increased. Your eyes and brain are a much more flexible system, when dealing with difficult light, than are your point-and-shoot and the film inside it.

Modern colour print film goes a long way toward capturing detail in bright highlights and dark shadows — an ability notoriously lacking in colour slide film. But even if your developed colour *negative* contains both shadow and highlight detail, the *print* may not. The photofinishing machinery may have to choose between one or the other because it can give the paper only one overall blast of light.

Don't despair: Here are several ways to trick your colour print film (and your prints) into keeping both highlight and shadow detail *when you're taking the picture.*

Use fill flash

Fill flash lightens the subject's shadows without significantly lightening the highlights. It brings shadows and highlights closer together. But keep in mind that fill flash helps only with subjects that are fairly close. When a subject exceeds the flash's outdoor range — perhaps 10 or 15 feet — fill flash doesn't make much, if any, difference. You can't use fill flash to lighten shadows in a landscape or a big building. But you *can* use fill flash to lighten the unflattering shadow on the side of someone's face or the distracting shady spots in your prize bed of roses. (See Chapter 5 for more on fill flash.)

Increase the exposure

First things first, increasing the exposure may be hard to do with your point-and-shoot camera. Fill flash, which you almost certainly *can* do, is generally a better remedy for hard light. But unlike fill flash, increasing the exposure works whether the subject is near or far — and its effect *can* make a difference with that building or landscape. However, unlike the other two techniques in this section, increasing the exposure works only with colour print film.

Increasing the exposure causes more light to strike the film than the camera would otherwise allow. This effect tends to reduce the negative's overall contrast, lightening shadows in the print.

One final note about increasing the exposure to cope with hard light: If your photofinisher makes a print that's washed out, ask for a reprint. Don't let them blame it on an overexposed negative; in most cases, the *print* just needs more exposure. (Negatives from one-time-use cameras are often quite over-exposed, and they print fine.) Adjusting the print settings just takes extra time on the part of the technicians.

Use a reflector

A *reflector* is a white or shiny surface that you use to bounce light into the subject's shadows and thereby lighten them. A big piece of white poster board will do. Foam core is a better idea; it's a white-surfaced, Styrofoam-filled art board that is both lightweight and rigid. You can also use a bedsheet or other white cloth, but you may need to attach it to a board for rigidity and control.

To use a reflector, place it on the side of the subject *opposite* the light source so that your subject is between the light source and the reflector. For example, if the sun is to the right of your subject, place the reflector to the subject's left. Adjust the reflector's distance from the subject and its angle until you see a visible lightening of shadows. Don't move it too close to the subject or you may lose the sense of shadow altogether; remember, shadow is important in defining the light's quality and direction and the subject's shape and textures. Also, be sure to keep the reflector outside the picture area. You may need an assistant to hold it in just the right position.

You'll be amazed at the way a reflector lets you control the balance of highlights and shadows. It can even fix overhead sun: Underneath a person's face, it immediately fills in those shadowy "holes." And a reflector is great for close-ups, too. I know one nature photographer who habitually tears paper out of his field notebooks and places it around the edges of his close-up subjects to brighten small shadows. Needless to say, this technique doesn't work with large-scale subjects; you can't use a reflector when you're shooting a landscape, unless it's specifically to fill a shadow in the immediate foreground.

Wrap your reflector in aluminum foil or silver mylar (available at art supply and hobby shops) to make it bounce light more efficiently. Covering the reflector allows you to use it at a greater distance from the subject. You can even substitute gold mylar to warm up shadows.

Capturing Light at the Right Time

Some pictures that are about light are about *momentary* light — light's more fleeting effects. A familiar landscape can be transformed when the sun breaks through a stormy sky and sends out shafts of dramatic light. Or for a short time in the spring, at a certain time of day, the sun may glint off a window and fill your yard's shadows with an interesting bounced light. Like most pictures of people, pictures of such lighting effects are hard to anticipate — and when you see them, you've got to act fast to capture them on film.

But for other pictures, you can — and should — wait for the right light. Say you're overlooking the Grand Canal of Venice or Lake Ontario. Both spots command a spectacular view, and you want pictures for posterity. You may think that the things in the scene are what make it great: the bobbing gondolas below, or the breathtaking stand of trees that surrounds your lake vista. And they do help make the scene; but content alone does not make the photograph great. You have to think about *light* to make the picture as great as its subject.

Midday blues

If you shoot your scene in the middle of the day, you're likely to be disappointed. If the day is sunny, you'll probably get strong shadows, which can give the scene a disjointed, hard-

to-read appearance. The direct light also may make colours look less intense than you remember when you get the pictures back.

Midday sun *can* be an interesting light source if handled with care. Pictures of mid-Manhattan buildings with midday sun, for example throw ornamental detail into high relief — a sharply defined, three-dimensional appearance. With some subjects in nature — valleys and canyons, hillsides and riverbeds — if you shoot too early or too late, you don't get any sunlight in them at all. And high noon is just about the only time, for example, that you can get decent pictures of slot canyons — those narrow, water-sculpted gorges of the American Southwest. The sun can't get inside them any other time.

Generally, though, you may want to stay away from midday sun. Needless to say, it can be as bad for portraiture as it is for landscapes, creating harsh, unflattering shadows in eye sockets and under the nose.

Shooting early or late in the day

You're usually better off taking pictures at the beginning or end of the day — when the light is more angular, less harsh, and warmer. Outdoor photographers have a special name for the warm-coloured, low-angle light that they get early and late on a sunny day: *sweet light.*

Your sweet-light photograph needn't be a landscape or a grand view. You can wait for sweet light to do a portrait session in your backyard, or to capture that gnarly detail of your old oak, or to take those close-ups of flowers you've been meaning to shoot. For sweet-light shooting, use a fast film — preferably ISO 400.

Cloudy is beautiful

A lot of inexperienced photographers avoid cloudy days like the plague. They think the light is drab. They're wrong. By lowering contrast and softening or eliminating shadows, cloudy days bring a special delicacy to subjects. They let subjects' colours and tones speak for themselves, without being drowned out by direct sun.

Cloudy days can actually *intensify* colours. Pictures of flowers or fall foliage are often more vivid in overcast than in direct sun. So if you're on a leaf-peeping trip and the day is cloudy, don't worry, be happy!

When you can't count on clouds to soften hard sun for a portrait, take your subject into open shade. You can find it under a tree, beside a house, under a beach umbrella, and so on.

Shooting in Special Kinds of Light

People don't spend all their time in the great well-lighted out-doors, of course. (Well, a few do.) For most people, light more often comes from various nooks and crannies: windows, open doors, skylights, electric lamps, overhead fluorescent bulbs. And light often comes at odd angles — from the side or back or even below your prospective subjects. These kinds of light call for different ways of shooting.

Window light

Window light can be hard or soft: direct beams of sun or indirect, scattered rays. Either way, it's beautiful. Having to squeeze through the window's rectangle and enter a room from one side gives light a striking directional quality and rich shadows, even when the light outside is shadowless. Studio photographers covet north-facing windows in particular, because they're lighted by an open sky and rarely get direct sun. North light, they call it.

Window light offers a unique photographic lighting opportunity, one worth exploring to avoid the monotony of indoor flash shots. Rather than blast away with flash, try bringing indoor subjects — a newborn or a vase of flowers — over to a window for pictures. Or set up a formal portrait session beside a window. For best results, get your subject fairly close to the window, where the light is brighter. And because moving closer makes the window's area larger relative to the subject, the light is softer overall, helping keep shadows lighter.

Keep your eye on shadows created by window light. The difference between them and the bright, highlighted parts of the subject can be even more extreme than outdoors because

there's so little scattered light indoors, in a dark interior, to fill in shadows. (There's a lot more scattered light outdoors.) This lack of scattered light can make the print have either washed-out highlights or dark, empty shadows.

Here are a few ways to prevent this effect, and you can combine most of them to suit your purposes:

✔ **Turn up the room lights as much as possible and/or move a lamp closer to the subject on the side opposite the window.** This adds light to shadows, but keep in mind that it appears as a *warm* light in the print because of the way your colour print film sees artificial light.

✔ **Angle your subject slightly toward the window, so the light strikes the subject not directly from the side but a bit more frontally.** With a portrait, this positioning allows more window light to spill into the shadowed side of the subject's face and body. Better yet, ask your subject to look toward the window.

✔ **Use a reflector.** Placed on the room side of the subject (the side opposite the window) outside the picture area, the reflector bounces the window's light back into the subject's shadows.

✔ **Use fill flash to lighten window shadows, but only if the light on your subject is direct sun.** Flash usually over-powers indirect window light, destroying the sense of its angle and quality. If the flash fires on its own, set the flash-off mode and take another picture. (See Chapter 5 for more on using fill flash.)

✔ **Use a fast (high ISO) film.** A fast film is especially impor-tant if you're shooting by indirect window light. The slower (lower ISO) the film, the longer the shutter speed the camera sets — increasing the risk, already substantial in such low light, that blur will ruin your picture. ISO 800 film is good for this purpose, ISO 400 as a bare minimum. And a high ISO film doesn't excuse you from holding the camera as steady as you can. Brace the camera on something if you want to play it safe.

✔ **Manipulate the window's treatments.** Sometimes you can change the quality of window light just by doing so. If the window has translucent curtains or translucent blinds, you can use them to soften direct sun. You can adjust horizontal or vertical blinds to create interesting

slitted patterns of sunlight or to control where the light falls. If your window is bare, cover it with layers of wax paper or tracing paper to diffuse sunlight. Even a dirty window adds interesting texture and pattern to light!

Artificial light

Indoor light — the illumination from household lamps and ceiling fixtures — may seem to be a light of mere convenience, but it has a photographic quality all its own. Because your colour print film is designed to produce the most accurate colour in daylight or with flash, it sees the light from tungsten and halogen bulbs as very warm in colour. Pictures taken by such artificial light end up with a yellowish or brownish-yellow cast — an effect that can be quite rich.

The strength of that effect depends heavily on photofinishing because automated printers can partially correct the yellowish cast. Some correction is good; otherwise, the effect may be so brown that the print lacks a sense of colour. If this happens, ask for a reprint.

To shoot exclusively by household light, you may have to turn off your flash by setting the camera's flash-off mode. Otherwise, your flash may fire automatically and overpower the light. Use an ISO 800 or even faster film so that the camera sets shutter speeds high enough to counteract blur due to hand shake. In fact, with an ISO 800 film, the camera may not fire the flash anyway because the film has enough light sensitivity for a good exposure.

On the other hand, you may *want* to mix warm tungsten light with flash illumination. Set your camera to slow-sync flash mode or, if it doesn't offer slow-sync, to fill-flash mode. Set these modes even if the flash is firing on its own (that is, in autoflash mode) because it will otherwise overpower the existing light. (Again, stick with ISO 800 film.) Mixing flash with tungsten light creates an interesting two-toned effect in which the foreground (the main subject) is mostly lighted by flash, and the background (where the flash doesn't reach) is mostly lighted by existing light.

Finally, if your room is lighted just by fluorescent lamps, avoid shooting with room light alone. Fluorescent light ends up green in pictures, though again, the photofinisher may be able to correct this cast a bit in printing.

Steadying your camera

When shooting in fairly low light — whether by a window, by artificial indoor light, or at dusk outdoors — your point-and-shoot may have to set a fairly slow shutter speed to get enough light to the film for a good exposure. In fact, some point-and-shoot cameras can set shutter speeds as slow as a quarter or a half a second, or even longer. A slow shutter speed means that if you don't hold the camera steady, your pictures may be ruined either by a visible blur or (almost worse) an annoying lack of sharpness — an effect called *shake*.

In low-light situations, advanced photographers may resort to *tripods* — three-legged collapsible supports that not only keep the camera steady but also allow you to control composition and your point of view more precisely. You can even use tabletop tripods — miniature versions that must be used on elevated surfaces

and that let you angle the camera in any direction. But other (free) steadying strategies exist as well.

One is simply to steady your arms against your body, specifically, pushing your upper arms into your chest as you shoot. At the same time, you can spread your legs widely, turning yourself into a "bipod" — a human tripod. Or, if a vertical surface is near your shooting position — for example, a wall or door frame — you can lean against it as you shoot.

Finally, if you can find a table, chair, ledge, or shelf that suits your point of view, rest the camera on it as you take the picture. However you brace the camera, be sure to press the shutter button smoothly — no stabbing motion allowed. You can also set the camera to self-timer, take your hands off, and have the camera fire by itself (see Chapter 2).

Backlight

Backlight is just what it sounds like: light coming from behind a subject. Sometimes it's the main light source; in this case, a subject is said to be backlit. Backlight can be beautiful, defining a subject by glancing off its sides and/or throwing it into shadow. It's the classic light for silhouettes. But backlight is also one of the most difficult kinds of light for a point-and-shoot camera to deal with.

The problem, usually, is that the camera sees lots of light in a backlit scene even though the main subject is shadowy. So it chooses an exposure that may not get enough light from the

main subject to the film. The result is a print in which the main subject is too dark — unless you do, indeed, want a silhouette. If you don't, here are a couple of ways to prevent or minimize the effect.

✔ **Move closer to the subject, or if you have a zoom lens, zoom in tighter so that the subject fills more of the picture area.** By cutting out more of the surrounding area, you lessen the peripheral light that can throw off the exposure. The problem with this approach is that it may cramp your compositional style — forcing you to compose more tightly than you'd like.

✔ **Set your camera's fill-flash mode.** By brightening the main subject, the added flash helps balance it with the brighter background. A few more sophisticated point-and-shoot models may actually fire the flash on their own when they detect that the middle of the scene (the main subject) is significantly darker than the surrounding areas. Fill flash works only if a backlit subject is within the flash's range.

✔ **Set backlight compensation, if your camera offers it.** Backlight compensation does its job regardless of the subject's distance. Many cameras have this feature; it forces the camera to increase the exposure, improving the sense of detail in the main subject. A few more advanced models provide automatic backlight compensation when they detect that the center of the picture area is substantially darker than the surrounding areas.

The problem with backlight compensation is that it gives as much extra exposure to the background as the foreground. The resulting print may in turn lack background tone or detail — a penalty you don't suffer when you use fill flash to fix backlight. Depending on the properties of the light, backlight compensation may also cause light to spill over and around the edges of the main subject, making it appear somewhat flat or foggy. Fogginess is a special risk with backlit subjects because you are often shooting *into* a light source such as the sun, which can result in flare.

Chapter 7

Composition 101 (Suitable for Framing)

*W*hether you put it in a fancy frame, every photograph really comes with its own built-in frame: the picture's edges. The viewfinder tells you where those edges fall within the scene you want to capture. Adjust the edges' placement by moving the camera around (aiming it up, down, or sideways); by moving yourself around (getting closer or farther away, or moving to the right or left); and/or by zooming.

Framing the subject is an important part of *composition* — how you squeeze, shape, and cajole reality into that little rectangle, which eventually becomes your print. But framing isn't the *only* part of composition. Other simple and effective techniques can improve your composition, from shooting the subject at an unusual angle to setting up depth-enhancing relationships between the scene's foreground and its background.

Composition Rules

Composition is the sum of all the visual tricks a photographer uses to make a picture pleasing and/or challenging to the eye. It starts with where you place the edges of the frame —

basically, what section of a scene you choose to put on film. But composition also includes how you lead the viewer's eye around the picture, how you control interrelationships between elements of the scene, and the ways in which you emphasize one part of the scene over another. Composition is especially important in photography because, unlike painting, you can't invent or rearrange reality. As a photographer, you have to work with the physical facts of the scene in front of you. But those facts can be interpreted and presented in different ways.

Composition is an endeavour in which anything goes — if it works. Good photographers regularly and effectively violate all the visual conventions handed down from painting and other graphic arts. One is the *Rule of Thirds,* which dictates that the most satisfying compositions are those in which important elements (especially the main subject) fall along a grid of lines that divides the scene you're shooting into vertical and horizontal thirds. This rule is not worth the paper it's often written on, so you don't find it in this book. Besides, the great thing about photography is that experimenting with composition is cheap. For the cost of a few frames of film and a handful of prints, you can compose your subject in various ways — and then decide which works best when you get your pictures back.

This chapter suggests several experiments to get you thinking about composition. Composition is worth thinking about, because when it's good, it can make a huge contribution to the quality of your photographs. Remember, though, every shot can't be a compositional masterpiece, nor does every subject warrant a lot of thought. But you can train yourself — your eye, really — to put that frame around your subject in an interesting and appropriate way, and to apply ideas that help you present the subject in a visually satisfying form.

Aiming versus Framing

Most photographers use a camera's viewfinder like a gun site. Basically, they centre whatever they're shooting; the viewfinder may as well have crosshairs in it. This mistake is understandable. Photographers get so caught up in the moment they're trying to capture that they forget they're also putting a frame around it.

The classic example of this compositional no-no is in people pictures. When most photographers look through the viewfinder, their eye is immediately drawn to the subject's face. And it

locks there, the face dead centre in the frame, with empty space above the subject's head. For better composition when you're photographing people, place heads near the top edge of the viewfinder frame, not in its centre. To do so, you must aim the camera slightly down.

Whether you're shooting people or things, to compose effectively you need to see and use the entire viewfinder area — to unlock your eye from what first caught your attention, whether it's a face or a big red barn. Every time you look through the viewfinder to take a picture, scan its edges. (If you have an autofocus point-and-shoot, remember that the little marks in the middle are for focusing, so don't let your eye settle there.) Notice the distance between things in the scene and the edges of the viewfinder frame — whether those things are far away from the edges, just touching them, or cut off by them.

Composition is much easier if you think of it in terms of creating relationships between the edges of the viewfinder frame and things in the scene. Point the camera up to place a landscape's horizon line near the bottom edge of the viewfinder frame, for example, so that the horizon will be low in the picture. Or swing the camera to the side to place a person closer to the right- or left-hand edge of the frame, so that the person will be off-centre in the picture. Or point the camera down to place a face closer to the top of the frame — a simple adjustment that includes more of the subject's body in the picture.

Keep your eye close enough to the viewfinder eyepiece so that you can see the entire frame. If you don't, you may end up with a picture that is unexpectedly off-centre, includes things you don't want, or leaves too much space and extraneous detail around your subject.

Balancing Foreground and Background

As you compose a photograph, keep in mind that a print reduces a three-dimensional subject to a flat plane, lessening the sense of depth your eyes and brain provide. But one way to restore that sense of depth is by choosing a shooting position from which you can include interesting foreground elements — objects in the near distance. Including interesting foreground elements is especially important when you're

Zooming versus moving

Zooming is fun. Unfortunately, the fun of it (and the ease of standing there and looking through the viewfinder as you rock the zoom switch or push the zoom buttons) seems to have convinced point-and-shoot photographers that zooming is the main way to control composition. It absolutely, positively is not! Zooming in and out is no substitute for composition. Real composition requires two legs.

If your point-and-shoot has a zoom lens, recruit a cooperative friend or family member — someone who'll stay put while you take a few pictures of him or her. Place your subject against an interesting background so that you can include a fair amount of detail along the edges of the viewfinder frame. Zoom your lens to a focal length around 70mm. (If you've got a 35–70mm model, just zoom it to its longest setting; if your model zooms longer than 70mm, any middle position around 70mm or a bit beyond is fine.) Compose so that your willing

subject fills a pretty big part of the frame. Then take a picture.

Next, zoom your lens to its shortest focal length; on most point-and-shoots, this will be 35mm or 38mm. Setting a shorter focal length gives the lens a wider angle of view, so you get more of the scene in the picture — and as a result, the person will be smaller. Look through the viewfinder and move closer until he or she is *the same size in the frame* as in the first, farther shot. Now take another picture.

When you get your prints back, compare them. You'll be surprised: The closer shot (the one taken at 35mm or 38mm) will actually show *more* of the background than the shot taken from farther away (the 70mm version). Oddly enough, the farther you get from the main subject, provided you keep zooming in to keep it the same size, the less and less background detail will be included in the picture.

photographing scenes without people close by. If you're photographing a landscape, for example, try to compose so that natural or manmade things — a tree branch, plants, rocks, or a portion of an architectural structure — occupy part of the foreground. Photographers sometimes call this approach *near-far composition*.

If you want to include foreground objects to enhance the sense of depth in your pictures, use as short a focal length setting as possible. On 35mm zoom point-and-shoots, this setting is usually 38mm or 35mm; some models may offer a 28mm setting. On Advanced Photo System (APS) zoom models, the shortest setting is usually 30mm, 26mm, or somewhere in between; a

few models may offer a 24mm or 21mm setting. These shorter focal lengths provide the wider angle of view needed to take in both foreground and background.

Single-focal-length (non-zooming) point-and-shoots are often well suited to creating strong near-far relationships. Their one focal length is often shorter than the shortest focal length on a zoom point-and-shoot. Also keep in mind that vertical composition can make it easier to create near-far relationships, especially if the close object is sitting on the ground, such as a rock, tree stump, or cluster of flowers.

One visually pleasing variation on the idea of near-far relationships is to frame a more distant subject with something in the foreground — to create a sort of frame *within* the photograph You can do this with window frames, doorways, arches, or natural elements. Scout around for these prospects before you shoot a subject.

Composing Off-Centre

One tried-and-true compositional technique that works with nearly any kind of subject, from people to landscapes, is to place the main subject off-centre in the frame rather than centring it. Set up your shot so that a person standing in front of the scene is off to one side in the picture, and then devote the other side entirely to the background, allowing you to show a bigger swath of the background, or to give it more visual weight. The visual imbalance created by this type of composition also gives the photograph a more energetic quality than does a centred composition, which tends to create a static feeling.

If your point-and-shoot is an autofocus model and you use off-centre composition, be sure to lock the focus on the main subject before shooting. (See Chapter 4 for details on locking the focus.) Locking the focus before establishing your final composition prevents the camera from focusing on the background and keeps the main subject sharp.

Changing Your Angle

Moving sideways before you take a picture is almost instinctive, if only to be able to photograph your subject from the front. But chances are you don't give much thought to moving up

and down, to changing the *height* from which you shoot. You probably take nearly all your pictures from your own standing eye level, whether it's 5'2" or 6'2".

A low angle can make an ordinary-sized subject look monumental, sometimes comically so. It also tends to minimize receding planes — a field, a floor, a basketball court. And a low angle radically changes the relationship between the main subject and its background. Photograph your kids from your own eye level in the backyard and you'll probably get mostly grass, and all the junk in your yard, behind them. Lie down on the ground and aim the camera up at them, though, and the background will probably be trees, sky, or (if you're not so lucky) the upper half of the neighbour's house.

But a high angle can simplify a subject, too. In particular, it lessens the overlap of objects at different distances; it helps you see over one object to the next. Even a little extra height — standing on a rock or chair — can accomplish this; with indoor shots, it produces a much different look than you're accustomed to. For outdoor shots, you may even want to shoot from a second-floor window, stand on a car, or (if you're limber enough) climb up a tree. This extra height gives you a clear shot of a large group of people, a good wedding and party trick, because you can literally see behind the people in front.

Shifting Sideways

Shifting sideways to take a picture does much more than let you shoot a subject from a more head-on position. If you've ever got back a picture in which the subject's head seems to be sprouting a tree or impaled by a telephone pole, a sideways move would have been the preventive medicine for that photographic affliction.

Small shifts in your lateral position — a mere few inches — can prevent objects at different distances from overlapping in confusing and unattractive ways. Bigger moves — a couple of feet — can entirely change a subject's background, replacing a cluttered or drab background with one that's simpler and more colourful.

As with all such movements, carefully study the subject through the viewfinder — your canvas — as you change your position.

Rotating the Frame: Horizontals versus Verticals

It's understandable that photographers shoot many more horizontal pictures than vertical ones. One reason is lack of thought, reinforced by a camera that is usually easier to hold and operate horizontally than vertically. Another reason is that most of the things you photograph are themselves horizontal, including landscapes and groups of people. However, lots of subjects can benefit from vertical composition. In fact, photographers shoot way too few vertical pictures.

Pictures of individual people are usually better as verticals. If you're photographing an individual, unless there's a compelling reason for horizontal composition, turn the camera on its side and shoot a vertical. For a head-and-shoulders shot, composing vertically rather than horizontally eliminates unnecessary background on either side of the subject and also lets you fill the frame more fully with the subject.

 When you shoot vertical pictures of people with flash, try to hold the camera so that the flash is at the top. Orienting the camera this way causes light from the flash to strike the subject from slightly above the lens angle, rather than below. This effect is usually more flattering to people, especially when you're shooting from a fairly close distance.

 Vertical composition is also useful when setting up a near-far relationship in a photograph. (See the section "Balancing Foreground and Background," earlier in this chapter.) Why? Because the camera "sees" a wider swath of the scene in its long dimension than its short. Beyond that, vertical composition can also lend a certain abstract quality to your pictures, showing a *piece* rather than the *whole* of a subject. It's more unexpected, and more surprising, than horizontal composition, since the majority of pictures taken are horizontals.

So even when your first inclination is to shoot a horizontal picture, consider vertical composition. (All it takes is a quick turn of the camera!) Instead of backing up for a horizontal shot that includes the whole subject — say, a building or a landscape — try shooting a vertical section that crops the subject at either side of the frame.

If you have an APS point-and-shoot, try taking verticals in the 4 x 7-inch *H* print format. The extra inch of height over the usual 4 x 6-inch size makes *H* verticals fun both to shoot and to look at. But with a little thought, you can even shoot vertical panoramas.

And what about horizontal composition? You certainly don't have to be convinced to use it; it is composition's default orientation. It can be more effective, however, if you place the main subject off-centre — that is, on one side or the other of the frame. As noted in "Composing Off-Centre," earlier in this chapter, this not only makes your composition more dynamic but also allows you to set up more interesting relationships between foreground and background.

Working the Subject

Sometimes you have just one shot at a subject — literally. Whether it's the expression you've waited for in a portrait, a telling gesture in a candid, or an instant of spectacular light in a landscape, the moment you capture is the picture you want, even if right after you shoot it, a better way of composing it occurs to you. Don't lose the moment because you're fiddling with composition.

On the other hand, the more attention you pay to composition, the more it becomes second nature. And when composition becomes second nature, you can have things both ways — capturing the moment *and* composing it in a visually appealing and meaningful way.

Fortunately, not all subjects are so transitory that they limit you to one picture. Now, there are subjects (even those static enough to allow more than one shot) with which only one way of composing clearly seems best: where only one combination of distance from the subject, shooting height, zoom setting, and, of course, framing seems to bring all their elements together in the most effective way. Other times, the right composition isn't always immediately apparent. So when the time is available and the subject isn't going anywhere, try to shoot it in as many different ways as possible. You won't know what's best until you get your prints back!

Chapter 8

Snapping Action

● ●

In This Chapter

▶ Showing action with still photos

▶ Prefocusing ahead of the action

▶ Overcoming your point-and-shoot's time delay

▶ Using fast film to freeze action

▶ Freezing action with flash

▶ Showing action with blur

● ●

*A*ction photography could just be the most popular and admired form of picture taking, especially in our sports- and fitness-happy society. But when you think about it, it's really a remarkable contradiction.

Action photography captures *movement* — in *still* photographs! — precisely what makes action photographs so compelling. The still photo, taking a brief moment of a continuing action — be it a pro sports play or a budding gymnast somersaulting in the backyard — lets you look at the action again and again. A great action shot is an instant captured for an eternity. In this chapter, you find out what you need to know to capture action with your point-and-shoot. Action photography has less to do with equipment than it has to do with timing, anticipating the critical moment and honing your reflexes to hit the shutter button when it arrives.

Your Dawdling Point-and-Shoot

Point-and-shoot cameras can have their quirks when you're trying to shoot fast action. You've probably noticed that your point-and-shoot doesn't necessarily fire right away when you press the shutter button, perhaps because the flash needs to

recharge some more or because the camera takes a moment or two to focus. But the other problem is that the lens aperture — the window in the lens — isn't very big on most point-and-shoots. So the window has to stay open longer to gather light from the subject, making it hard to stop the action cold.

You can often overcome these problems, though, with special action-oriented techniques. Some techniques require a bit of practice. So get ready to shoot a lot of film!

If you plan to practice shooting the same action over and over, you can save a great deal of money by getting the film developed (made into negatives) but not printed. Later, you can look at the negatives and get the best takes printed. If you use an APS camera, you can get the film developed, plus an index print only. (With 35mm, you can get an index print for a couple more dollars, if your photofinisher offers this service.) The index print makes it easier to pick out the good frames.

The Anticipation Game: The Art of Prefocusing

To be a good action shooter, you have to keep your point-and-shoot from dawdling when you press the shutter button. The only way to do so reliably is by mastering a technique that may sound weird at first: Set up a photograph completely and be ready to shoot *without* your subject in the frame. Yes, you read that right. And now for the details.

For good action shots, *prefocus* your subject — that is, make the camera focus *before* the subject enters the picture. You could call this *surrogate focusing* because you prefocus on something that's at about the same distance, and in about the same light, as your action subject.

Prefocusing is basically the same thing as locking your focus. (See Chapter 4 for more on this.) The difference is that you lock the focus a little ahead of time — before your subject has entered the viewfinder frame. Here's how to prefocus your action subject:

1. **Choose a stationary object that your moving subject will pass by at a close distance.**

Some possibilities: a tree, a fence, third base, the goalpost, a parked car, even a friend or bystander.

2. **Lock the focus on the object.**

 Centre the viewfinder's focus point on the object and press the shutter button halfway down to lock your focus.

3. **While holding the shutter button halfway down, re-aim the camera to establish your desired composition.**

 Compose so that your action subject — say, skateboarder or runner — will be entirely within the frame when you shoot.

4. **Hold that focus until your subject enters the frame.**

5. **Push the shutter button all the way down to take the picture.**

Prefocusing is a crucial skill in action photography; every action technique described in this chapter requires it. But if you haven't fully mastered the procedure needed to lock your point-and-shoot's focus, you may have a little trouble. Now's the time to practice until you have it down pat. For action prefocusing, you should be able to lock the focus and hold it for a long time — as long as 30 seconds. Practice with an unloaded camera for a shooting finger of steel!

Frozen or Blurred Action?

A camera gives you two main ways to convey a sense of action in a still photograph. One is by *freezing* the action — that is, taking a picture within such a short time interval that the subject seems to stop cold. (Indeed, such photos are sometimes called *stop-action* shots.) The other way to convey a sense of action is by capturing the subject's movement across space — in plain terms, *blurring* its motion.

Freezing and blurring are really just variations on each other. You can think of the stop-action shot as a thin slice of time: the tennis racquet frozen in midswing with the ball suspended in midair. Blurring, on the other hand, is a thicker slice of time: the tennis racquet and player's arm forming a wide, blurry arc across the picture frame, the streak of the tennis ball ahead of it.

Freezing action with fast speeds

To freeze action effectively, you need to take as thin a slice of time as possible. One way to do this is with a fast shutter speed. The other method of stopping action is to use electronic flash, which illuminates your subject with an extremely short burst of light. Though you can sometimes use flash outdoors for action, the best way to stop action in bright light is with a fast shutter speed.

Different point-and-shoots have different top shutter speeds — that is, the shortest (or, more correctly, the *highest*) shutter speed they can set. Some models can set only wimpy top speeds of ½₅₀ second or ½₀₀ second. Others go as high as ⅟₇₀₀ or ⅟₁₀₀₀ second. Most current point-and-shoot cameras above $100 have a top shutter speed of about ⅟₅₀₀ second — not too shabby. This speed is usually high enough to freeze a runner, making his arms and legs motionless in midstride. If the camera can only go as high as ½₅₀ second, the runner's arms and legs may show signs of blur.

You've probably noticed that you can't set the shutter speed on your point-and-shoot. *The camera sets the shutter speed for you.* After all, you bought a point-and-shoot camera so that you wouldn't have to worry about stuff like that, right? So, when you want to shoot action subjects, how do you make sure your camera sets as high a shutter speed as it can? Use fast film.

Fast action requires fast film! If you want to stop action, use as fast a film as possible in your camera. Even outdoors, use ISO 800 film. In lower light, or for indoor action, you may want to go with an ISO 1600 colour print film, or even an ISO 3200 colour print film. Not sure that your camera accepts fast film? Take another look at your camera manual's specifications page to find out. If you don't have a manual, open up the back of your unloaded camera and look in the chamber where the film cassette goes. If you see four metallic contacts in a row, your camera most likely uses films up to ISO 3200 in speed. If you see only two or three contacts, your camera is limited to ISO 400 or 800.

Because fast film needs less light than slow film to make a good picture, using it means the shutter — that window in the lens — need not stay open for as long a time. In other words, your camera sets a higher shutter speed, provided the light is reasonably bright to begin with. And this higher shutter speed freezes the subject better.

Finding the decisive moment

If you've already taken pictures of fast action, say, base running or diving, you may have noticed a pattern. Your little slugger is already past the bag. Or the belly flop is just a splash. Even if you prefocus the shot, you *still* have a short delay between when you press the shutter button and when the shutter actually opens for the shot. And that delay can combine with your delay in reacting to the subject's action to make you miss the slice of time you meant to cut.

A slight time delay when taking pictures of your toddler toddling across the backyard probably amounts to half a baby step — not so critical. But with a speeding two-wheeler, it's another story. Say that you prefocused on your backyard fence in anticipation of the cyclist's arrival; if you wait to push the shutter button until the bike is *centred* in the frame, it may be *out* of the frame by the time the shutter opens.

The trick is not only to anticipate the moment when your subject will reach the correct position but also to fire *slightly in advance* of it. To get that two-wheeler, for example, you may have to press the shutter button when the bike is just halfway into the viewfinder. Try keeping both eyes open as you look through your camera so that you can see your action subject approaching out of the corner of your nonshooting eye. You can also prefocus, hold the shutter button halfway down, and look *over* the camera to see your action subject is approaching. Then look back through the viewfinder at the last second to snap the picture.

Freezing action with flash

Your point-and-shoot camera has a not-so-secret weapon for taking stop-action photos: built-in electronic flash. Use flash for action shots indoors, as well as outdoors in low light or at modest distances.

Electronic flash freezes action effectively because it is, oddly enough, a slice of time within a slice of time. When you take an ordinary flash shot with your camera set to autoflash, the shutter opens for a period that is usually too short to expose film properly by existing light. But within that brief time the shutter opens, the flash fires. Electronic flash is basically a very bright spark with a very short duration. Because the flash

lights your subject only for that short spark, it nicely freezes your subject in the picture.

Using flash to stop action involves pretty much the same techniques as shooting stop-action pictures in existing light. Prefocusing is particularly important with flash action shots. For one thing, pressing the shutter button halfway keeps the flash charged up. For another, your autofocus camera has to know the distance to the subject to determine the proper flash exposure.

Autoflash is the best flash mode for indoor action shooting. It keeps the shutter open a fairly short time, the flash providing most or all of the light for the picture. But if you have very fast film and are shooting in a well-lit area, you may find that your camera suppresses the flash. In this case, just change the camera from autoflash to fill-flash mode.

You have to worry about three things when using flash for action shots: Distance, distance, distance. If you're too far from the subject for your flash to light it properly, you get a weak, muddy picture. So always use at least ISO 400 speed film, and preferably ISO 800, for indoor flash action. Move in as close as possible to the action, which makes your pictures better anyway. And zoom out to wider-angle focal lengths, which make your lens's window bigger, admitting more light and giving your flash range a boost.

Showing action with blur

Freezing action is fun, but blur isn't necessarily a bad thing. A trace of blur in the subject often says *action!* more than a completely frozen effect. And, depending on your point-and-shoot, you may get some degree of blur with any action subject, even with an ISO 800 film.

If you want even more blur, moving the camera is one easy way to get it. You can move your camera against the direction of the action, or at angles to it. You can even jiggle the camera or move it up and down. In other words, *you* can add the blur. If you do it right, the blur will look as if it's somehow the consequence of the subject's movement, not what you did with the camera.

In the mode for action

Many point-and-shoots have specialized modes that make action shooting a little easier — though they're no guarantee of good results. Some modes are described further in Chapter 2. But here's a specific look at how you can use these modes for action shooting.

✔ **Sports or action mode:** On most point-and-shoot models, this mode turns off the flash and sets the motor to continuous film advance mode. You can fire off shots for as long as you hold down the shutter button.

✔ **Multiple flash:** Firing the flash several times in a single exposure, this mode gives you interesting effects on gymnastics, dancing, or other fast movement in a small area.

✔ **Multiple exposure:** This mode prevents film from automatically advancing to the next frame, so you can layer several pictures on the same frame. It gives interesting results on indoor events such as gymnastics floor exercises in autoflash mode.

✔ **Snap mode:** A fast-firing mode that turns off the camera's autofocus, prefocusing the lens at snapshot range — about six feet, use this mode for subjects such as rambunctious kids so that you don't have to prefocus.

The Last Word on Action

While your local sandlot softball league or high school track team can provide you with great action photo ops, remember that action subjects need not be limited to sports. The world around you is full of action ready for the shooting. A trip to your local zoo, for example, may net a leaping monkey or a diving polar bear. Going to a wedding? Take your point-and-shoot with you onto the dance floor, set it to slow-sync flash, and snap away for some wild and crazy shots, guaranteed. And don't forget graduation action shots. No kidding! Almost every graduation has some kind of post-ceremony horseplay, and you can always snap the graduate leaping in the air. And be sure to bring your weatherproof point-and-shoot along when you take the kids sledding.

One other note: Try not to get so carried away with capturing action that you forget to compose. Doing both takes practice,

but even if your subject is fast moving, you're still putting a frame around it.

Finally, remember that some of the best action pictures are of the human drama after an event: an exhausted marathoner pouring water over his head, Little Leaguers mobbing the pitcher after the game-winning strikeout. So don't put your camera down after the action has officially stopped. The game-winning play, after all, can be pretty dull — a called third strike or the deliberate downing of a football to run out the clock. Your reflexes and anticipation as a photographer count after the final buzzer, too!

Chapter 9

Simple Ways to Make Better Pictures

. .

In This Chapter

▶ Capturing the moment

▶ Framing the subject thoughtfully

▶ Using your flash — outdoors!

▶ Getting below — or above — eye level

▶ Shifting your camera position

. .

*P*eople who claim they're constitutionally incapable of taking good pictures — not technical enough, not artistic enough, or just don't have access to good subject matter — are wrong on all counts.

A rich profusion of subject matter surrounds each of us, from luminously quiet moments of family life to the play of light in backyards. You don't need exotic places or people to make great pictures. And, thanks to point-and-shoot, you don't have to be the slightest bit technical to get good picture quality. Exposure, focus, flash is all handled for you, and the results are remarkably consistent.

You also don't have to be artistic to take good pictures. You just have to use some visual intelligence, to think with your eyes. Much of that visual thinking can be reduced to the simple notions in this chapter.

These tips apply to any point-and-shoot camera, from fancy designer ones to simple, one-time-use models. You don't need a pricey point-and-shoot — or even autofocus — to make them work for you.

Capture the Moment

Not to co-opt Kodak, but most personal photography is about moments. Keep in mind, though, that moments can be unique or everyday. Don't wait for a specific occasion to take your pictures; find telling moments in seemingly ordinary events. Also, remember that moments are, by definition, fleeting. To catch that perfect expression or charming interaction, you have to anticipate it. Keep your finger on the shutter button, your eye to the viewfinder, and your patience.

Don't Use the Viewfinder like a Gun Sight

"Shooting" is an apt description of how most picture-takers compose, placing their main subject dead-centre. (Crosshairs may as well be in the camera's viewfinder.) Heads always seem to end up smack in the middle of a picture, with empty space above. For people pictures, vertical or horizontal, place heads near the top of the picture area.

Photographers often get so caught up in the moment they're trying to capture that they forget they're also putting a frame around it. Thinking about framing a subject while trying to capture a moment is a little like rubbing your stomach and patting your head at the same time. It takes concentration. See Chapter 7 for more on composition.

Get Close

Try to fill the frame with your main subject. Most pictures suffer from the subject's being too small. In most cases, the best way to fix this — the only way, with a nonzooming camera — is simply to move in closer. Unless you're shooting a tight portrait, zooming to fill the frame is often not a good idea. In fact, your own two legs are the most important photographic tool at your disposal: Use them to move in and out, and thus to control the subject's size in the frame.

If your point-and-shoot doesn't autofocus — often called a "focus-free" camera — you shouldn't get closer than about

four feet from your main subject. If the subject is closer than that, it probably won't be sharp in the print. The same thing goes for one-time-use cameras.

Shoot from a Low or High Angle

Your own eye level is not sacred. If you've stooped to shoot pictures of kids, you know this instinctively. Shooting from a child's-eye level makes more intimate contact. And with taller subjects, human or inanimate, aiming the camera up from a low angle can create an interesting monumental effect. (Again, legs are your tool here. Squat!)

Shooting from a high angle is a bit trickier. You may have to climb a wall or atop a car, or perhaps shoot from a deck or window. But even a little extra elevation on a subject can keep foreground and background elements from overlapping confusingly, adding depth to an image.

Use Flash Outdoors

Your point-and-shoot automatically fires its flash in dim light, but you shouldn't think of flash just as a way to add light to a subject without enough to shoot by already. Flash is a great idea when you must shoot in direct sunlight; it "fills" dark, unattractive facial shadows created by a subject's eye sockets and nose. Flash also helps brighten a "backlit" subject that would otherwise end up too dark.

On the other hand, an outdoor subject with delicate lighting may be overpowered by flash (rosy light at the end of the day, for example). And if you're shooting a landscape, don't bother — it's too far away for the flash to make any difference. When in doubt, shoot pictures with *and* without flash and then compare the final results.

Keep Flash Backgrounds Close

If a background is too distant for the flash to light, the print may make your subject appear to be surrounded by a dark void. (Photofinishing worsens this effect, trying to compensate for

the darkness and making the main subject too light.) While you're at it, choose a colourful background. If you don't have the luxury of moving a subject around, two other things can improve background detail: use slow-sync flash mode, if your camera has this mode, and switch to faster film.

Use a Fast Film

Don't be talked into a print film that has a lower speed than ISO 400 unless you plan to make big blow-ups from it. Current fast films — ISO 400 or even ISO 800 — give you prints of exceptionally high quality. Their extra sensitivity to light not only reduces the risk of slow, image-blurring shutter speeds but also lets you shoot without flash in a wider range of existing light. Just as important, it improves background detail in flash shots.

Move from Side to Side

A small shift sideways can make a huge improvement in a picture, preventing objects at different distances from over-lapping horizontally and creating visual confusion. Study the viewfinder as you move to see how a change in lateral position can change the relationships among elements of the scene.

Experiment with the Horizon Line

Usually, anything is better than placing a landscape's horizon line midway up the frame. Put it at the bottom instead, and you can emphasize a sky, for a "big" effect. Place it near the top, and you can create a strong feeling of depth.

Take Lots of Pictures

Film is cheap. Photography's great pleasure is that you can learn what works by trying it, for the cost of a frame of film and a print.

Chapter 10

What to Try If Your Camera Won't Shoot

- -

In This Chapter

▶ Pressing the right buttons

▶ Reloading the film

▶ Checking your batteries

- -

*N*othing is more frustrating than spotting a picture-perfect subject and being unable to get your point-and-shoot to shoot it. This chapter offers some remedies, but if these suggestions don't get your point-and-shoot shooting, take it to a photo dealer. If they can't solve the problem, your camera may have to be repaired. Keep in mind that buying a new camera is often cheaper and easier than repairing an older, inexpensive one.

Even if working properly, most point-and-shoots let you shoot *when no film is in the camera.* So don't snap away only to realize — after all those great pictures — that your camera is shooting blanks. If you haven't used your camera in a while, check the window on its back (35mm models only) to make sure that a cassette is in place. Or check the frame counter to make sure that it moves from one number to the next as you fire (both 35mm and APS models). If the frame counter is not moving, the film probably isn't advancing.

If your camera starts but then acts up, try turning it off and on again. It's a bit like restarting a crashed computer: It sometimes clears the camera's electronics or software chips of whatever is troubling them.

Turn the Camera On Correctly

If your camera won't start up, you may be pressing the wrong button. Check your manual to find out which button is right. Also, make sure that you're pressing the button all the way in; sometimes you have to briefly hold it down to get the camera to react. Cameras that sport both dials and pushbuttons may start up only when you rotate the main dial to any position other than *Off;* if your model has more than one dial, make sure that you're using the right one. And with models featuring sliding front panels, you turn on the camera by sliding out the panel to uncover the lens. The panel must click into shooting position. If it slips back in as you clutch the camera to shoot, it turns off the camera.

Reload the Film

If a 35mm point-and-shoot doesn't engage film properly, it won't let you take pictures. When this problem occurs, the camera usually flashes an *E,* for empty, on its LCD panel. (Models lacking LCD panels indicate this problem by not advancing the film counter to *1,* remaining stuck on *0.*) Open the camera back, take out the film, and load it again. (See Chapter 1 for specifics.) If using an APS model and you inadvertently loaded an exposed or already processed cassette, the camera won't let you shoot either. Find an unused roll and load it.

Replace the Battery

Even when a battery is too weak to run the camera, it usually has enough power to display or flash a low battery icon on the LCD panel — again, if it *has* an LCD panel. (For more about this icon, see Chapter 1.) Less expensive models may not have an LCD panel; you may have to press a battery-check button, which lights up a lamp to tell you the battery is okay. Otherwise, the only way to find out whether your battery is the culprit is to change it.

Make Sure the Battery Is Correctly Installed

If a battery is installed backward — that is, with the ends reversed — the camera can't get any juice. If your particular

model takes more than one battery, just one incorrectly installed battery out of two, three, or four puts you out of business. (If your camera has an LCD panel, an incorrectly installed battery causes a blank display.)

Printed or embossed insertion diagrams or symbols are inside the battery compartment or cover, and occasionally on the outside of the compartment. They show you which way to orient the end of the battery with the bump on it, which is its positive (+) terminal.

Clean the Battery Contacts

If a battery sits in your camera for a long time, leakage of its acidic contents may corrode the compartment's *contacts* — the metallic points with which the camera draws power from the battery. Corrosion usually leaves a whitish powder, but it may not always be visible.

To clean the contacts, open the battery compartment, remove the battery, and vigorously rub a pencil eraser against the top and bottom contacts in the compartment. If your battery goes in lengthwise rather than sideways, rub the eraser against both the terminal deep inside the camera and the terminal on the compartment cover or cap. Then blow out the eraser fragments and replace the battery with a new one. A battery that has already leaked is likely to do it again, gunking up your camera all over. Plus, a leaky battery loses some of its energy.

If you use your breath to blow out the compartment, rather than a blower brush or compressed air, shut your eyes to avoid getting dust in them. If you use compressed air (available at photo shops), keep the canister upright to avoid squirting propellant into the compartment.

Check the Flash-Ready Lamp

If shooting in dim light, make sure that the flash-ready lamp glows steadily. The flash-ready lamp (usually red or orange) is either on the viewfinder eyepiece or on the edge of the viewfinder frame as you look through the camera. If the lamp is *blinking*, the flash hasn't fully recharged; the camera won't fire when you press the shutter button. (A one-time-use model, however, fires the flash even if only partially charged.) Wait to shoot until the flash-ready lamp glows steadily (especially with

one-time-use models). If the flash takes a long time to charge — ten seconds or more — you may need fresh batteries.

When your camera starts, it automatically charges the flash — even when the light is bright — so that it's ready if you use flash to fill dark shadows. So if you try to take a picture immediately after you turn the camera on, the charging cycle may prevent the camera from firing when you press the shutter button, especially if your battery is weak. Just wait a few seconds and then try shooting again. If you don't use flash, subsequent shots won't be slowed by flash recycling time.

Step Back from the Subject

When too close to a subject, the lens on an autofocus point-and-shoot may not be able to focus; if the lens can't focus, the camera won't fire. Most models tell you whether you're too close by rapidly blinking a viewfinder's focus-OK lamp, a green light in the eyepiece. (Check your manual for its exact location.) If this lamp is blinking, let up on the shutter button, move away from the subject a foot or two, and try again. If the focus-OK lamp glows steadily, you should be able to shoot — provided the flash has recycled, of course!

Cameras without autofocus let you take a picture even if you're too close to the subject. In this event, the picture will not be sharp. Check your manual to find out how close you can get to the subject and remember not to get any closer.

Rewind the Film and Insert a New Roll

It doesn't happen very often, but sometimes film snags on the cassette or the camera. This problem may be caused by physical damage to the cassette, which in my experience is more likely with 35mm than the Advanced Photo System. To rewind the film, push the midroll rewind button. (Check your manual for its location.) See Chapter 1 for details.

Glossary

● ●

*P*hotography had its own jargon long before the high-tech buzzwords of the computer era. And naturally, more terms come into being as new camera and film technologies are introduced; the Advanced Photo System (look it up!) is responsible for many recent additions. But most terms in this glossary are decidedly old-fashioned, so they're not just for impressing your friends. Use them with the old-timers at your local photo shop — correctly, of course — and see their eyes light up.

35mm: The type of film used by most point-and-shoot cameras, which is why they're called 35mm point-and-shoots. It comes in a cassette with a protruding film leader.

Advanced Photo System (APS): Breakthrough camera and film technology that has created a new generation of point-and-shoots, APS offers a choice of three print formats, improved photofinishing, and significant storage and reprinting conveniences.

Angle of view: The amount of a scene taken in by a particular lens focal length. Short focal lengths have a wide angle of view, allowing you to photograph a larger portion of the scene than long focal lengths, which have a narrow angle of view.

Autoexposure: The system with which your camera automatically sets the lens aperture and shutter speed to get the correct amount of light to the film.

Autoflash: Flash mode in which the camera automatically decides whether flash is needed, turning the flash on in dim light and keeping it off in bright light. It's the default mode of most point-and-shoots.

Backlight compensation: Adjustment of exposure to prevent the subject from turning out too dark when light is coming from behind it.

Backlight: Light coming from behind the subject. When light from behind is the main source, the subject is said to be backlit.

Camera shake: The unwanted movement passed along to your camera by involuntary hand and body tremors, it's a major cause of unsharp pictures.

Catchlights: Tiny highlights (bright spots) in a subject's eyes, caused by reflections of the light source.

CCD (charge-coupled device): A tiny "chip" that is digital point-and-shoot's equivalent to film. A CCD uses rows of microscopic sensors to measure and record light energy, which is then stored digitally.

Colour saturation: The relative brilliance with which a film (or print) reproduces the subject's colours. Films that deliver more intense colours are said to have high saturation.

Composition: The process of adjusting framing, camera position, and/or focal length to turn the subject into a visually appealing photograph.

Contrast: The degree of difference between a subject's tones, a function of its inherent shades and colours and also of the quality of light.

Correct exposure: The specific amount of light that must strike a given film to produce the best possible picture quality.

Cropping: Masking or otherwise shaping a photographic image to change its proportions.

Default: A mode, or group of modes, that a point-and-shoot always returns to after settings are changed for a particular shot or roll.

Developing: See *photofinishing*.

Diffused light: Light that has been softened by cloud cover or any other translucent element.

Digital: Pertaining to computer language and operation. A digital point-and-shoot captures and stores pictures without film, for direct use in computer software and printing applications.

DX code: The bar code on the side of a 35mm film cassette that automatically tells the camera what film speed (ISO) to set for correct light metering and exposure.

Exposure latitude: The range within which a film can tolerate errors in exposure and still produce acceptable results.

Exposure value: Abbreviated EV, always with a plus or minus number attached, it indicates the degree of exposure change with exposure compensation or backlight compensation — for example, +1.5 EV, –0.5 EV.

Exposure: The amount of light that strikes the film when you take a picture. Also, a frame of film — enough for one shot.

Fast film: Film with a high sensitivity to light, reflected in its high ISO rating — usually ISO 400 and above.

Fill flash: (Also known as *flash-on.*) Flash mode in which the camera fires the flash for every shot. Fill flash can be used to soften shadows in bright outdoor light by filling them with light.

Film cassette: The small, lightproof housing in which film is supplied, and that you place in the camera to shoot. With 35mm, the film cassette is discarded after processing; with the Advanced Photo System, it's returned to you with the processed negatives inside.

Film leader: The short, half-width strip of film extending from an unexposed 35mm cassette; must be engaged in the take-up spool for a camera to advance the film.

Film speed: The measure of a film's sensitivity to light, film speed is indicated with an ISO number — ISO 400, for example. The higher the number, the more sensitive the film.

Film winding: (Also called *film advance.*) Moving a roll of film from one frame to the next for each shot, often by built-in motor.

Flash: Your point-and-shoot's built-in light source, the flash fires in an action-stopping burst and often has several different modes.

Flash-off mode: A mode in which the flash won't fire regardless of the light level. It may cause the camera to set a slow shutter speed.

Flash-ready lamp: A small light beside the viewfinder window or next to the viewfinder frame, it blinks when the flash is charging and glows steadily when the flash is ready to fire. Usually red or orange.

Focal length range: The run of focal lengths offered by a zoom lens. It's specified by the shortest and the longest, in millimetres — for example, 38–90mm.

Focal length: Technical term indicating how wide or narrow a section of a scene the lens includes in a picture (angle of view), and/or how big or small it makes the subject (magnification).

Focus point: Small brackets, lines, or a circle in the middle of an autofocus point-and-shoot's viewfinder indicating where the camera is focusing.

Focus-free: (Also called *fixed-focus.*) Term for point-and-shoots that have no autofocus capability. With these models, the lens's focus is preset at a medium distance that gives reasonably sharp results with any subject about four feet away and beyond.

Focusing: In-and-out adjustment of the lens to make the main subject sharp on the film.

Focus-OK lamp: (Also called an *autofocus confirmation lamp.*) A small light beside the viewfinder window that blinks when the camera can't focus a subject and glows steadily when focus is achieved.

Frame counter: The display that tells you how many shots you've taken, or are left, on a roll of film. The frame counter may be located on the camera's LCD panel or in a small separate window.

Frame lines: Light or dark lines or brackets just inside the viewfinder frame that indicate the area of the scene that will be recorded on the film. (Many point-and-shoots do not have frame lines.)

Frame numbers: Numbers printed by the manufacturer along the edges of 35mm film, or by the photofinisher on an index print or the back of a print. Frame numbers allow you to identify a particular negative for reprinting or blowups.

Frame: The rectangle that you see when you look through the viewfinder, used for viewing and composing the subject; or one picture's worth of film; or that thing you put your prints in.

Grain: Tiny clumps of silver crystals that form the photographic image during film development, their pattern is sometimes visible in the print. The faster the film, the more visible the grain — but even fast films are now very fine-grained.

Hard light: Light that creates strong contrast and heavy shadows in the subject, usually from a direct source such as the sun or a lightbulb.

Icon: A symbol representing a specific mode or status, it's displayed on the camera's LCD panel or printed on its body.

Index print: Created by digital scanning, a print-sized sheet of tiny positive images of every shot on a roll. Used for storage, indexing, and reprinting reference.

Infinity lock: Often called landscape mode, this setting causes the camera to focus as far away as possible; especially useful to prevent misfocusing when shooting through windows.

ISO number: See *film speed.*

LCD (liquid crystal display) panel: Found on all but the least expensive point-and-shoot models, it indicates camera status and settings.

Lens aperture: The window in the lens that lets light through to the film. Your point-and-shoot automatically adjusts this window's size, called the f-stop, to control the exposure.

Lens: A cylinder of shaped pieces of glass or plastic at the front of a camera, it projects a tiny image of the subject onto the film.

Light meter: The built-in device that your point-and-shoot camera uses to measure light and determine the correct exposure settings.

Light source: The immediate origin of a scene's light, such as the sun or a window.

Locking the focus: Pressing and holding an autofocus point-and-shoot's shutter button halfway, to prevent the camera from refocusing incorrectly with your final composition.

Long focal length: See *telephoto focal length.*

Midroll rewind button: Used for rewinding a roll of film before it's finished (that is, fully exposed).

Mode: A setting that causes the camera to perform a specific function or operation. See Chapter 2 for detailed definitions of specific modes.

Muddy: Term for prints that are lacking in detail, contrast, and colour brilliance (often grayish or brownish).

Negative: Used to make the print, it's the visible form a picture takes after the film is processed. A negative's tones and (with colour print film) colours are the opposite of what they were in the subject, but printing reverses them back to their original state.

Normal focal length: Focal length setting — usually around 50mm with 35mm models, 40mm with APS models — that reproduces the most natural-looking size relationships in a scene.

One-time-use camera: A model designed to shoot a single roll of film, it's available in specialized designs, and comes in both 35mm and APS versions. You turn in the camera itself to the photofinisher when the roll is done.

Panorama mode: A setting in which the camera produces an elongated image intended for the creation of a 4 x 10- or 4 x 11½-inch print.

Parallax error: The difference between what the lens sees and what you see through the camera's viewfinder; especially pronounced at longer focal lengths and with closer subjects.

Photofinishing: (Also called *developing* or *processing*.) The business of turning exposed film into negatives (developing) and negatives into prints (printing) — or into any other usable, visible form.

Pixels: Short for picture elements, the tilelike bits of colour and tone that form a digital image.

Positive: Opposite of negative, used to describe any photographic image that reproduces the subject's original tones and/or colours. A slide is a positive; a print is a positive.

Prefocusing: Same idea as locking the focus, but using the technique to reduce shutter-button time lag when shooting a moving subject.

Print format: The proportions (height to width) or shape of a photographic print. The Advanced Photo System offers a choice of three print formats, selectable with a control on the camera itself.

Processing: See *photofinishing*.

Quartz-date: Term for point-and-shoot models with the ability to imprint the date on photographic negatives; numbers appear permanently on the front of the prints.

Random Access Memory (RAM): The amount of active digital storage in your computer, RAM must be relatively high to allow work with photographs.

Resolution: Technical term for measuring photographic sharpness, resolution is lower for digital point-and-shoots than film models.

Rewinding: The process of retracting a roll of exposed film into its cassette before removal from the camera. Motorized on many models, rewinding starts automatically at the end of the roll or when you press the midroll rewind button.

Scanning: The process of translating a photograph (negative or print) into an electronic form that can be used by computers.

Self-timer mode: A setting in which the camera delays taking a picture by a specified interval after you touch the shutter button.

Sharpness: The degree to which clear, distinguishable details of the subject are rendered in a photographic negative or print.

Short focal length: See *wide-angle focal length.*

Shutter button: The button that you press to take a picture. On autofocus cameras, the shutter button also activates and locks the focus when pressed halfway.

Shutter speed: The length of time the window in the lens stays open to let light through to the film.

Single-focal-length: Term for lenses on non-zooming point-and-shoots. Because the focal length cannot be adjusted, you can only control the subject's size in the picture by physically moving yourself and the camera in and out.

Slide film: Film designed to produce a positive transparent image of the subject on the original film. Mainly intended for projection or scanning rather than printing, though you can order prints from slides.

Slow film: Film with relatively low sensitivity to light, reflected in its lower ISO rating — usually ISO 200 and below.

Slow-sync flash: (Also known as *night, night scene,* or *night portrait mode.*) This mode combines flash with a longer shutter speed to improve background detail in low-light flash shots.

Soft light: Light that creates delicate tones and pale or minimal shadows in the subject, such as from a cloudy sky or in open shade.

Telephoto focal length: (Also called a long focal length.) A focal length setting — usually around 60mm (with APS) or 70mm (with 35mm) and beyond — at which the subject is magnified (appears bigger than normal in the frame).

Thumbnails: Small reference images of the shots on a roll, appearing in an index print or on a computer screen.

Toggling: Pressing a pushbutton repeatedly to advance through a menu of modes, in order to choose and set one.

Viewfinder: Window on the camera through which you see the frame used to view and compose your subject. (On many digital point-and-shoots, the viewfinder is a TV-like colour LCD screen.)

Wide-angle focal length: (Also called a short focal length.) Focal length at which the lens takes in a relatively large section of the total scene. Most point-and-shoot zoom lenses start out at a wide-angle setting (38mm, 28mm), and most non-zoom models have wide-angle lenses (35mm, 32mm).

Wide-area autofocus: (Also called multibeam or multipoint autofocus.) An autofocus system in which multiple focus points cover a wider-than-usual area in the middle of the viewfinder. Wide-area autofocus allows the camera to focus subjects that are slightly off-centre without the need to lock the focus.

Zoom lens: A lens of adjustable focal length. You zoom to increase or decrease the lens's magnifying power, making the subject bigger or smaller in the frame.

Zooming in: Setting a longer focal length on your zoom lens, to make the subject bigger in the picture.

Zooming out: Setting a shorter focal length on your zoom lens, to include more of the scene in the picture.